HIDDEN
HISTORY
of the
SEBAGO
LAKES
REGION

Marilyn Seguin

HIDDEN HISTORY
of the
SEBAGO LAKES REGION

Marilyn Weymouth Seguin

THE
History
PRESS

Published by The History Press
Charleston, SC 29403
www.historypress.net

Copyright © 2015 by Marilyn Weymouth Seguin
All rights reserved

First published 2015

Manufactured in the United States

ISBN 978.1.62619.851.7

Library of Congress Control Number: 2014958797

This book is dedicated to my grandsons,
Ben Seguin and Will Trombitas.
My loves.

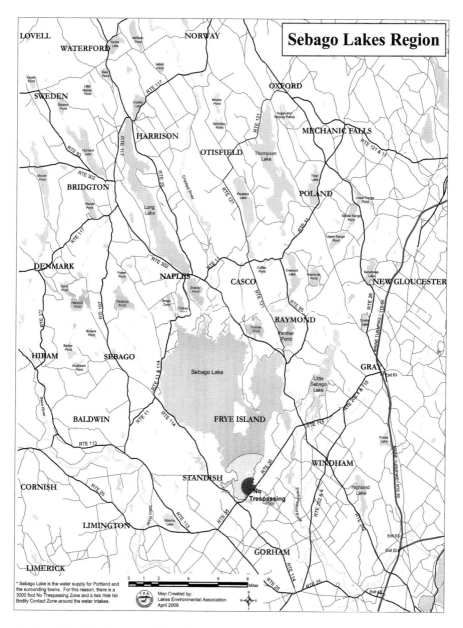

Courtesy of the Lakes Environmental Association.

CONTENTS

CONTENTS

ACKNOWLEDGMENTS

I learned to love and appreciate hidden history from my beloved folklore professor, the late Dr. Sandy Ives, at the University of Maine in Orono in the early 1970s. In the summer of 1972, when I was an undergraduate English major at the university, Dr. Ives hired me to transcribe oral histories at the Northeast Archives of Folklore and Oral History in the basement of Stevens Hall. Everything that Dr. Ives taught me, in class and on the job, informed me about the importance of collecting and writing down the hidden history that is so often not revealed in the dry accounts of more "scholarly" work. I am grateful to Dr. Ives for instilling in me a love of folklore and legend.

I am especially thankful to the members of the many active historical societies in the Sebago Lakes Region for taking the time to share their local histories and image archives: Karen Taylor, Audrey Burns and Richard Skilling of the Gray Historical Society; Mary Watson of the Naples Historical Society and Information Center; David Tanguay of the Windham Historical Society; Mary Chipman and Louise Roberts of the Poland Historical Society; and Wayne Holmquist, Pamela Grant, Irene Morton, Mildred Dingley, Betty McDermott, Frank McDermott, Paul Edes and Dana Rand of the Raymond Casco Historical Society.

Thanks to several folks who enlightened me about possible Underground Railroad activity in the Sebago Lakes Region: author Caroline Grimm, historian Andy Grannell, Quaker Ridge Meeting House preservation activist Betsy Crofts and Professor Daniel Crofts of the History Department at the College of New Jersey. Any errors are absolutely my own.

ACKNOWLEDGMENTS

Librarians are a writer's best friends, and I appreciate the efforts of the staff at the Gray Public Library who were always able to locate the research materials I sought. Thanks also to Sally Holt of the Raymond Village Library. Thank you, Tammy Voelker, research librarian for the English Department at Kent State University, for locating the old Walter Gibson Shadow scripts that so eluded my own search.

A few stalwart souls traipsed around with me as I uncovered pieces of the Sebago Lakes Region's hidden history, including lifelong friend Mary McNeil, who alerted me to several legends included in this collection. Thanks also to gravestone carving expert Ron Romano who spent a morning with me exploring gravestones in Portland's Eastern Cemetery. Thank you to Helen and Perley Witham, who, over the years, have invited me along on excursions to historical destinations in the Sebago Lakes Region and all over the state of Maine.

I am grateful to my sister Linda Weymouth Markee who served as my beta reader. Linda has spent summers at her family camp in the Sebago Lakes Region for almost three decades. She knows the location well. Thanks to Katie Orlando and Elizabeth Farry, my editors at The History Press, for their support and encouragement. Finally, thank you to my husband, Roland Seguin, with whom I share my life's history.

INTRODUCTION

Folks who live in or vacation in the Sebago Lakes Region of Maine in the southern part of the state waste little time in getting into the water. There are more than fifty bodies of water in the district, but the largest is Sebago Lake, second in size only to Moosehead Lake in the northern part of the state. Sebago Lake is eight miles wide and ten miles long, and its waters are clear and blue, home of the landlocked salmon. Other lakes in the region include, among others, Little Sebago, Panther Pond, Crescent Lake, Sabbathday Lake, Long Lake, Highland Lake and Brandy Pond, whose shores are dotted with resorts, children's camps and seasonal cabins, as well as year-round residences. The region is a Mecca for fishing, swimming, boating and hiking, and the surrounding towns provide ample venues for eating, shopping and sightseeing.

The Sebago Lakes Region is rich in history, as well as in bodies of water, and that is what this book is all about. *Hidden History of the Sebago Lakes Region* recounts stories of persons who traveled through or settled and made their living in the area. Some of these characters were famous—novelist Nathaniel Hawthorne, poet Henry Wadsworth Longfellow and *The Shadow* author Walter Gibson, for example. Other characters made names for themselves in the local community because of their idiosyncrasies—Edgar Welch physically removed the top of a mountain in order to gain more sunlight, and Ben Smith earned a living by selling snake oil that he harvested from reptiles he found on the same mountain. Some of the tales in this collection recount tragedy and disaster, such as the 1856 brutal axe murder of Mary

Knight in Poland and the sad story of the Tarbox couple, who froze to death in a late spring blizzard just steps from their own door on Raymond Cape. Ghosts, gossip and curses also have an allure for most of us. Who is haunting the Old Anderson Cemetery in Windham? Could there be buried treasure in Raymond?

This collection of tales includes stories about people who lived and events that occurred from approximately 1675 to 2009. Some of these stories are not well known. Others have been reported in various media over the years. All of these events took place in the Sebago Lakes Region, defined for the purpose of this book by the town of Fryeburg on the west; Bridgton and Poland on the north; New Gloucester, Windham and Gray on the east; and Westbrook on the south.

Much of the information in this book comes from secondary print sources, and when possible, I have attempted to confirm the accuracy of the information from primary sources, including personal interviews, e-mails, letters and diary entries. Any stories told about people and events from the past are always subject to multiple interpretations. However, all of the tales in this collection contain elements of truth and verification, and all are meant to preserve the hidden aspects of documented regional history—the rumors, the mysteries, the quirky characters that make the history of the Sebago Lakes Region alive and memorable.

Part I

CONFLICT BETWEEN NATIVES AND SETTLERS

THE REVENGE OF SQUANDO, SAGAMORE OF THE SOKOSIS

Long before the white settlers came to the area, Native Americans populated the beautiful Sebago Lakes Region. When the settlers began to dominate the area, clearing the land, taking game from the forests and bringing disease, hostilities with the natives were bound to heat up. By 1675, there were seven thousand settlers in Maine and perhaps two or three times as many Native Americans.

When the English prohibited the sale of firearms and ammunition to the natives who relied on guns for hunting, it was the last straw. Squando of the Sokosis or Sokokis tribe—not to be confused with Squanto of the Wampanoag, who was taken to England by Captain Weymouth in 1605—was a powerful sagamore (leader) of his people. He was known to be a man of peace and a visionary. Squando claimed that the Englishman's God appeared to him as a tall man dressed in black and commanded him to stop drinking liquor, to keep the Sabbath and go hear the word preached. This he did for the rest of his life. Legend has it that Squando once returned to her family a young white girl who had been captured and raised among his tribe, and poet John Greenleaf Whittier lifts up this legend in verse in "The Truce of the Piscataqua."

The Sokosis inhabited the valley of the Saco, a river that rises in the White Mountains of New Hampshire before crossing into Maine, where it then makes its way into the Sebago Lakes Region. For a time, the Sokosis lived peacefully in close proximity to the white settlers, even though conflict was quickly building, culminating in what was to be known as King Philip's

War. Metacomet, known to the English as King Philip, was a Wampanoag who urged the New England tribes to confederate in order to push out the colonists. Squando and the Sokosis were living on friendly terms near the white settlements at this time, but things were about to change. Squando might have counseled peace to his tribe, even in the face of Metacomet's argument for war, had not an unfortunate personal tragedy taken place.

One summer day in 1675, an English ship came up the Saco River to anchor near Squando's village. Two English sailors aboard the vessel were discussing the inherent abilities of the natives. It was a common belief among the whites that the natives could swim as instinctively as an animal in the style of a dog paddle instead of a breaststroke, the swimming style of the Europeans. As the sailors were discussing this difference, Sakokis, the wife of Squando, her infant Menewee strapped to her back, set her canoe in the river and paddled by. The sailors set forth in their own boat and met the canoe in the river, upsetting it, throwing Sakokis and the baby into the river. The baby sank to the bottom, and Sakokis dove down to get him and then swam to shore, but little Menewee died. Not long after, under the leadership of Squando, the Sokosis tribe began burning villages and killing the settlers in the region. Squando said that supernatural visitors assured him that the colonists and their settlements would be destroyed in the end. Even when King Philip was killed in Rhode Island in 1676, ending King Philip's War in southern New England, the Sokosis continued to raid the Maine settlements for another eighteen months. Squando became one of the most dangerous men in Maine, and under his leadership, his men slaughtered many of the English military expedition at Black Point in 1677 before a truce was finally made between the natives and the English.

Squando's revenge is commemorated in Whittier's verse from "The Truce of the Piscataqua":

> *Squando shuts his eyes and sees,*
> *Far off, Saco's hemlock-trees*
> *In his wigwam, still as stone,*
> *Sits a woman all alone*
> *When the moon a year ago*
> *Told the flowers the time to blow,*
> *In that lonely wigwam smiled*
> *Menewee, our little child*
> *On his little grave I lay;*
> *Three times went and came the day,*

Thrice above me blazed the noon,
Thrice upon me wept the moon
At the breaking of the day,
From the grave I passed away;
Flowers bloomed round me, birds sang glad,
But my heart was hot and mad
There is rust on Squando's knife,
From the warm, red springs of life;
On the funeral hemlock-trees
Many a scalp the totem sees
Blood for blood! But evermore
Squando's heart is sad and sore;
And his poor squaw waits at home
For the feet that never come!

What happened to Squando? Apparently, the great sagamore received one last visit from the Englishman's God, who this time commanded Squando to kill himself, promising that if he did, he would come back to life the next day and never die again. Squando told his friends and wife about this visitation, and they wisely advised him against killing himself. However, Squando hanged himself shortly thereafter.

And that would seem to be the end of the story, except that Sakokis found her own brand of revenge for the death of their child. She sought out the medicine man of the tribe and asked him to cast a spell over the river at the scene of the tragedy. According to writer Celia Sturtevant, "He chanted his mystic words and poured his oblation of bad medicine into the stream, which summoned his Satanic Majesty, Hobowocko, who cursed the spot roundly, so that as long as the white man lives, the Saco waters must each year drown three of his hated race." In another version of the story, both a pregnant Sakokis and the infant Menewee lost their lives in the Saco River on that encounter with the whites, and it was Squando himself who placed the curse on the river. The enraged Squando said that three white men would drown in the river each year to replace the lives that were lost, and that this curse would be broken only if all whites fled from the region.

Today when there is a drowning on the 135-mile Saco River, some residents of southern Maine will relate this tale. A Google search will turn up media accounts of the curse whenever there is a drowning. According to Sturtevant, there are more drownings at one particular spot than in any other place on the river, "just where the waters smooth out below the falls."

Of course, the Saco is a favorite with swimmers, kayakers and anglers, but where there are dangerous waters, there will always be drownings. One Sebago Lakes Region resident told me that the curse was always in the back of her mind when her children were small and swimming in the Saco, which runs through her rural property in Steep Falls. There have been quite a number of deaths on the Saco since she moved there nearly three decades ago, and at least one body has floated by her dock since she has lived on the property, she said. In a field on the same property is a small graveyard established by another family who once lived in the house in which she and her husband raised their family. Rumor has it that one of the markers memorializes a nine-year-old boy who lost his life to the curse of the Saco River (James Manchester, 1834–43).

Frye's Leap and the Legend of Naragora

Rising out of Sebago Lake on the Raymond Cape shore is an eighty-foot-high granite cliff known locally as Frye's Leap or the "Images." The monikers give rise to several legends concerning this giant boulder. At one time, the rock face had strange Native American characters, or "images," painted on its surface, including a wigwam, a deer, a wounded bear and a war dance. Other images were said to depict the sad story of the princess Naragora.

Variations of the Naragora legend have been published widely. In one, Naragora of the Sokosis fell in love with a brave chief of her own tribe, but for reasons unknown, he was forbidden to marry. One night, the star-crossed lovers went out on the lake in a canoe, where they disappeared and were never seen again.

In a more popular version of the legend, Naragora, which means "gentle fawn," was the daughter of Waldola, an old hunter, and they made their home on the shores of Sebago Lake. Naragora was engaged to a young brave who was off fighting in Quebec. One day, a wounded white man named Lawson came to the home of Waldola and Naragora, and they took him in and fed him. Over the next several weeks, they nursed him back to health. During that time, Lawson fell in love with Naragora and one day asked her to marry him. Embarrassed, Naragora explained to Lawson that she was betrothed to a brave she soon expected to return from war in Quebec. Lawson was enraged by her refusal and threatened Naragora with an oath that she would never again set eyes upon her fiancé.

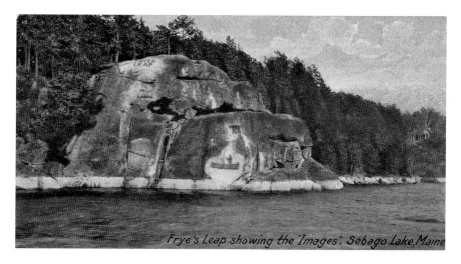

Vintage postcard of Frye's Leap or the "Images." *Author's collection.*

One afternoon not long after Lawson's proposal, Naragora went down to the lake and was gazing out upon the Sebago water when she was startled by a noise behind her. It was Lawson, who seized her roughly and hurried her off into the forest. That night when Lawson fell asleep, Naragora crept by him and made her escape back to her father before morning. Old Waldola believed that his daughter's safety depended on a swift removal from their lakeshore home. Father and daughter quickly packed a few belongings that they would need for their journey. But they were too late. Before they had a chance to escape, a party of white men led by Lawson emerged from the forest and fired upon Waldola, killing him. Terrified, Naragora ran off into the woods, Lawson pursuing. She ran for two miles, and soon she reached the summit of the huge granite boulder that rose out of the lake, but Lawson was upon her, and he shouted, "Ha, my bird! I have you! You will make me a fine bride among the Falmouth belles." Refusing to give herself up to Lawson, Naragora leapt from the cliff into the lake and disappeared forever beneath the water.

Another legend gave rise to the more popular "Frye's Leap" place name. Joseph Frye was born in Andover, Massachusetts, in 1712. In 1745, Frye enlisted in Hale's Fifth Massachusetts as an ensign and as a military man soon found himself serving in Falmouth, Maine, and then Scarborough. At the time, native hostilities were a great threat in the Maine territory. One winter day when he was alone, exploring the Sebago Lake area, Frye came upon a party of hostile warriors who chased him across the frozen lake to

the top of the cliff at the end of Raymond Point. Thus cornered, Frye had no choice but to jump or else be captured or killed by the warriors. Frye jumped, landed safely on the ice and ran across it to a nearby island. The warriors, surprised at this feat, gave up the chase. Today, the island is known as Frye Island, and the cliff is known as Frye's Leap.

There is an interesting footnote to the Frye legend. It is not a coincidence that the Frye legend sounds a bit James Fenimore Cooper-ish. Frye's military encounters may have actually inspired Fenimore Cooper's *The Last of the Mohicans*, a popular novel published in 1824 about the attack on Fort William Henry, located on the frontier between the province of New York and Canada. Joseph Frye, who was present at the siege of the fort in 1757, documented the events in his "Journal of the Attack on Fort William Henry." The account was not really a day-by-day account of events as they happened, but rather a recollection of events written at a later time.

It is easy to see why Frye's horrific account of Native American encounters could have become fuel for Fenimore Cooper's storytelling. In Frye's journal, the massacre at Fort Henry was described as follows:

> *Wednesday August 10th. Early this morning we were ordered to prepare for our March, but found the Indians in a worse temper (if possible) than last night, Every one having a Tomahawk, hatchet or some other Instrument of Death, and constantly—plundering from the Officers, their Arms &ca. This Colo Monro Complain'd of, as a breach of the articles of Capitulation, but to no Effect. The French officers, however told us, that if we would give up the baggage of the Officers & men to the Indians, they thought it would make them easy, which at last Colo Monro consented to. But this was no sooner done then [sic] they began to take the Officers Hatts, Swords, Guns & Cloaths, Striping them all to their Shirts, and on some officers left no Shirt at all. While this was doing they killd & scalpt all the Sick & wounded before our faces, and took out from Our troops, all the Indians and negroes and Carried them off. One of the former they burnt alive afterwards.*

According to writer Pat Higgins, the official copy of the journal is at the public records office in Kew, England. A draft copy of the journal was discovered among Frye's personal papers at his Fryeburg home by grandson Nathaniel Frye. Nathaniel released the journal for publication in 1819, and that is how James Fenimore Cooper would have had access to its content. Frye's original draft, in his own handwriting, is reportedly in the collection

of the Morristown, New Jersey Historical Park. Interestingly, there is no written account by Frye of the famous "Frye's Leap" incident, which makes the event suspicious according to some historians.

After the end of the French and Indian War, Joseph Frye turned his attention to acquiring a land grant in his beloved Sebago Lakes Region. In 1762, Frye was granted six square miles of land on the Saco River, and he began to plan the town now known as Fryeburg. He built his house and barn on a rise called Frye Hill. Eventually, as the population of his town increased, Frye held all sort of public offices and even operated a store out of his own house so that the locals would have a place to buy provisions. He also sought a liquor license.

Frye died on July 25, 1794, at the age of eighty-three in Fryeburg. During his life, his military service covered three different wars: King George's War, the French and Indian War and the American Revolution. During the Revolution, Joseph Frye was appointed brigadier general of the Massachusetts forces. But Frye's crowning achievement was founding the Lakes Region town of Fryeburg on the Saco River, and his legend sprang from his encounters with the natives.

3
JOE KNIGHT—CAPTURED!

When the white colonists cleared the forests and built their homes in the town of New Marblehead, now called Windham, they created a great deal of animosity from the Native Americans. In 1744, a bounty of one hundred English pounds was offered for every scalp of a male Native American over the age of twelve. The natives were understandably angry over this, as well as over the loss of their forest and game, and during this time, many white settlers were taken as captives in retaliation.

In New Marblehead, several young men were captured at different times during the mid- to late eighteenth century, but one of them had the distinction of being captured twice. On April 14, 1747, the natives, who had been quiet for many months, suddenly came out of the woods and captured brothers Joseph (Joe) and William Knight. The boys were taken captive while searching for their father's cows near Inkhorn Brook. William was shortly released, but the tribe adopted Joe. According to an account related by Joe's granddaughter Charlotte Knight Thomas, as reported in Dole's book *Sketches of the History of Windham, Maine*, Joe adapted very well to native life, and the natives seemed to like him as well. Joe married into the tribe, but on August 3, 1751, peace between the natives and whites was declared on condition that the white captives be returned to their families. Joe said goodbye to his native wife and returned to live with his parents in New Marblehead for the next five years.

Joe's father had established a sawmill at Little Falls, and Joe and his brother helped him in this work. One day in February 1756, Joe was out

in the forest cutting a pine at the edge of a clearing. Suddenly, he spotted a native hiding behind a nearby log. Joe stopped his labor and fled in the direction of the mill, but he was not quick enough. The native rose and discharged his musket at Joe, breaking Joe's arm. Here is where the story gets interesting.

The band of natives who captured Joe forced him to march miles into the forest. At nightfall, they stopped and built a fire and cooked some food. While Joe sat leaning against a tree holding his wounded arm, he watched the natives dig a hole in the ground. When the size of the hole began to resemble a grave, Joe thought that his final hour had surely come and that he would soon be murdered and buried where his family would never find him. When the natives had finished digging, they bound Joe's shattered arm tightly to his side and laid him inside the hole in the ground, packing the loose dirt around him but leaving his head exposed. Then they went to sleep, all except Joe, who was left to wonder what kind of torture he would have to endure in the morning when his capturers were fully rested.

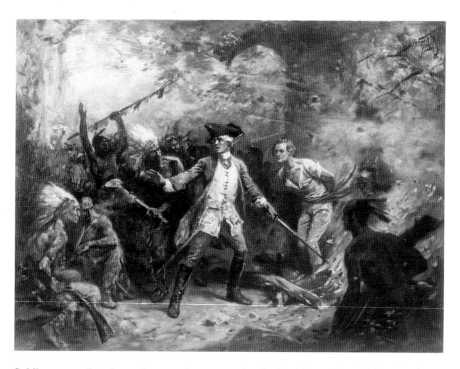

Soldier persuading the natives to release a captive, by Jean Louis Gerome Ferris. *Library of Congress.*

At daybreak, the natives unearthed the frightened Joe, and to his great relief they did not kill him. Joe was surprised to find that during his partial burial, his wounded arm had begun to heal quickly, and the pain had subsided. Joe remained a captive for several weeks, long enough to overhear the natives' plans to make a general attack on the white settlements in the area as soon as the scattered bands of tribes could come together. Joe bided his time but resolved to escape and warn the setters of the impending attack.

At the beginning of May, the bands began their advance on the settlements. According to Dole, Joe snuck out of the village and followed the warriors. According to Stephen Watson's account in *Maine Historical and Genealogical Recorder, vol. 5*, on May 7, 1756, the natives took Joe with them. The party marched through the forest and came to the banks of the Androscoggin River and camped for the night. This time, the natives didn't bury Joe in the ground to prevent his escape.

According to Watson,

> *It seems that the small party having charge of Knights [sic] were somewhat careless of their prisoner, their only precaution being to place him between two of the men to sleep upon the ground by the fire. The Indians soon fell into a heavy sleep, and Knights [sic] watching his opportunity crawled from between his guards and stole away without their notice, and after much wandering about, having to practice many cunning devices to baffle his pursuers, and suffering much from hunger while lying concealed by day, he came into the settlement at North Yarmouth on the morning of the 10th, and gave the alarm of the large war party and their intention of destroying the plantations from Brunswick to Saco. Messengers were at once dispatched to the neighboring settlements.*

Thus warned, the settlers were prepared to defend their settlements. The conflict known as the French and Indian War was now in full swing in the Sebago Lakes Region and elsewhere in New England.

As for the spot where Joe Knight was first captured, Inkhorn Brook was named when surveyor Rowland Houghton of Massachusetts came to lay out and measure the new town in 1735. Among his tools was an inkhorn, a section of animal horn hollowed out to hold the powder that made ink when mixed with water. When Houghton came to a brook overflowing with spring runoff, he struggled to cross the brook and dropped his inkhorn. Thus, the brook is forever remembered as Inkhorn Brook, and the town seal of Windham features the image of an inkhorn lying beside a stream.

THE BURIAL OF CHIEF POLAN

In the spring of 1756, old Chief Polan of the Sokosis tribe (known then to the locals as the Rockameecooks) gathered his braves together for an ambush on the settlers. The settlers had encroached upon the Sebago Lake shore lands that the natives had claimed as their campgrounds for centuries. Their numbers were reduced by disease and war. Polan believed the Sokosis had a score to settle. One of the settlers in particular, Stephen Manchester, was a sworn enemy. Manchester had vowed to kill Chief Polan, but the old chief was determined to kill Manchester first.

There was a fort in New Marblehead (the settlement wouldn't be named Windham until 1762) built in 1744 at the site of the present-day intersection of Anderson and River Roads. Polan and his braves planned to ambush the settlers when they left its protection and went out of its gates to do their planting. In the early morning of May 14, Chief Polan and his warriors came up the Presumpscot River in their canoes and landed somewhere near present-day White's Bridge.

On that morning, some of the white settlers, including Ezra Brown and Ephraim Winship, left the fort and headed for their fields a mile away where they intended to plant some corn. It was there that they were ambushed by Chief Polan and his warriors, who fired upon them, killing Brown and wounding Winship in the arm and head. The Sokosis rushed in and took their scalps. Curiously, Winship had a "double crown," so the warriors took two sections of his scalp, leaving a narrow strip of skin in

between. Winship eventually recovered from his wounds, but the attack left him blind in one eye and with a very peculiar appearance.

The other settlers in the field ran back to the fort, determined to form a party to follow the Sokosis. Among the men in this party was Stephen Manchester. When the settlers caught up to the Sokosis, the firing commenced. Chief Polan fired at Manchester but missed. Immediately, Manchester took aim at Chief Polan and fired, and the great leader of the Sokosis fell dead. The settlers killed two more braves before they fled, taking with them the bodies of their comrades.

According to legend, the Sokosis braves "swayed" or bent back a young beech tree until its roots were exposed. Beneath the roots, they placed the body of their chief and released the tree to cover the grave. When the Songo Lock was being converted to concrete in 1910, reportedly workers found human bones under the roots of a large tree. Could the bones have been the remains of Polan, as many believe?

New England poet John Greenleaf Whittier (1807–92) commemorated the burial of the chief in his poem "Funeral Tree of the Sokokis." The poet may have erred in the location of the grave, according to a footnote in Dole's book, *Sketches of the History of Windham, Maine: 1734–1935*,

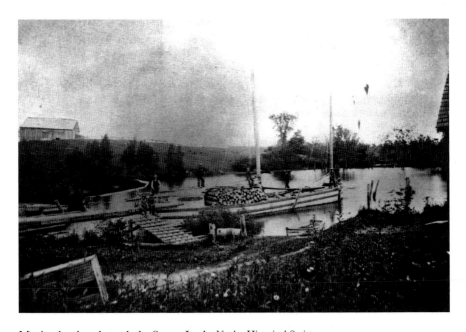

Moving lumber through the Songo Lock. *Naples Historical Society.*

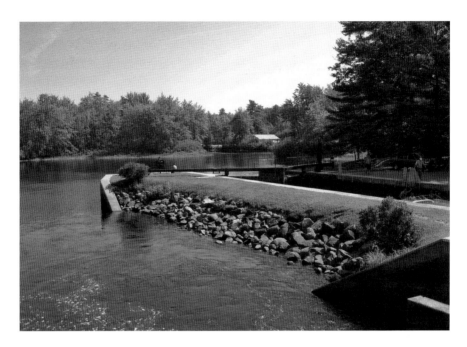

Songo Lock today is still operated by hand. *Author photo.*

The Story of a Typical New England Town (43). The Presumpscot River, not the Saco, is the outlet of Sebago Lake, and Chief Polan was slain ten miles from the lake, rather than "along Sebago's wooded side." Nevertheless, the poem gives a pretty good description of the legendary burial technique.

FUNERAL TREE OF THE SOKOKIS (excerpt)
Around Sebago's lonely lake
There lingers not a breeze to break
The mirror which its waters make.

The solemn pines along its shore,
The firs which hang its gray rocks o'er,
Are painted on its glassy floor.

Her tokens of renewing care
Hath Nature scattered everywhere,
In bud and flower, and warmer air.

But in their hour of bitterness,
What reek the broken Sokokis,
Beside their slaughtered chief, of this?

The turf's red stain is yet undried,
Scarce have the death-shot echoes died
Along Sebago's wooded side;

And silent now the hunters stand,
Grouped darkly, where a swell of land
Slopes upward from the lake's white sand.

Fire and the axe have swept it bare,
Save one lone beech, unclosing there
Its light leaves in the vernal air.

With grave, cold looks, all sternly mute,
They break the damp turf at its foot,
And bare its coiled and twisted root.

They heave the stubborn trunk aside,
The firm roots from the earth divide,—
The rent beneath yawns dark and wide.

And there the fallen chief is laid,
In tasselled garb of skins arrayed,
And girded with his wampum-braid.

The silver cross he loved is pressed
Beneath the heavy arms, which rest
Upon his scarred and naked breast.

'T is done: the roots are backward sent,
The beechen-tree stands up unbent,
The Indian's fitting monument!

When of that sleeper's broken race
Their green and pleasant dwelling-place,
Which knew them once, retains no trace;

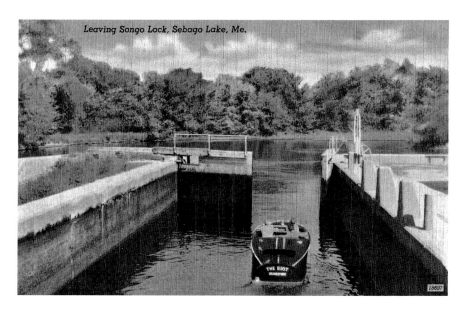

Leaving Songo Lock, Sebago Lake, Me.

Vintage postcard of a boat leaving Songo Lock. *Author's collection.*

Oh, long may sunset's light be shed
As now upon that beech's head,
A green memorial of the dead!

There shall his fitting requiem be,
In northern winds, that, cold and free,
Howl nightly in that funeral tree.

Part II

Characters—The Famous and the Quirky

BEN SMITH, THE SNAKE MAN

When Ben Smith came from Dover, New Hampshire, to Maine in 1787, he settled in the Raymond hills. Nearby was a long, low mountain—just a hill really. Smith found the mountain to be infested with rattlesnakes, probably timber rattlers, nonaggressive reptiles that range in length from three to six feet. Smith named the hill Rattlesnake Mountain and began his entrepreneurial venture. He caught the snakes, removed their fangs and extracted the oil. Smith bottled and sold the oil to folks suffering from rheumatism and neuralgic pain in Portland and across the Sebago Lakes Region countryside.

For centuries, snake oil had been a remedy for such maladies in Chinese folk medicine, and the idea eventually took hold in this country when Chinese immigrants came to work on the railroad. Most of the Chinese came between 1849 and 1882, long after Ben Smith began hawking his cure-all in Maine. He may have learned about the curative properties from sailors in Portland, as Maine merchant ships were active in the China Trade in the late eighteenth century (the United States entered the China Trade in 1784).

Ben Smith must have had some faith in the curative properties of his snake oil product because he reportedly carried around with him a box with live snakes in it. When he gave a sales pitch, Smith took one of the live snakes out of its box and placed it inside his shirt against his bare skin (he charged a fee for this stunt). He was bitten at least once, and his friends claimed that afterward, Ben acquired one of the characteristics of his reptiles—his tongue constantly darted in and out of his mouth.

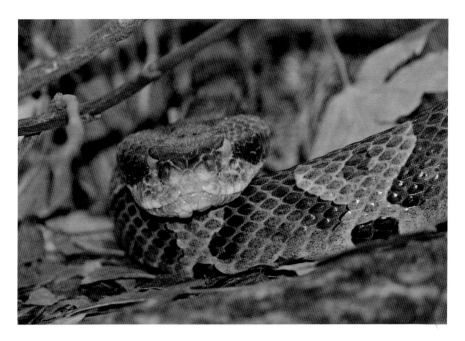

Timber rattlesnake. *Wikimedia Commons by L.T. Shears.*

Another local resident, Betsy Welch Libby (1775–1867), harvested rattlesnake oil to relieve her husband Seth's severe rheumatism. Betsy was the first female born in Raymond (then called Raymondtown), and she lived on the neck of land that reaches out into Panther Pond that bears her name today, Betty's Neck. Because of her husband's affliction, the full burden of running the farm and household fell to Betsy. According to a tale related by a local historian, the late Ernest H. Knight, one day Betsy went out berrying and on the trip killed a woodchuck and a rattlesnake. She walked the mile or more back to her house with the woodchuck tied to her waist on one side and the rattlesnake on the other. She carried two full pails of berries. The woodchuck and the berries provided supper for Betsy and Seth, the fat from the animal provided fuel for the lamp and the rattler provided oil for Seth's liniment. Betsy is buried in the Raymond Village Cemetery on the Mill Road, section A, lot 64.

In 1925, summer cottage owners on nearby Rattlesnake Pond in Casco changed the name of that beautiful body of water to Crescent Lake because they thought it sounded better, but the mountain's name has remained unchanged. Today, of course, there are no rattlers to be found on Rattlesnake Mountain. Reportedly, they were all destroyed during a fire caused by careless lumbermen. The last recorded capture of a rattlesnake was in 1870.

SCOTT LEIGHTON, WORLD FAMOUS PAINTER OF ANIMALS

As a child, Nicholas Winfield Scott Leighton loved to draw, especially animals. Known as Scott Leighton, he was born in 1847 in Auburn and grew up in Gray. Leighton came by his love of subject matter as a teenager. When he was fourteen, Leighton joined his father in the horse business in order to earn enough money to support himself as a painter. By the time he was seventeen, he had saved $2,000, so he headed for Portland to make a living as an artist. There, he painted portraits of horses, but he was not able to earn enough to support himself at this. (He received $2.50 for his first commission.)

Leighton married Sadie L. Wyman in Portland in November 1870; they had a church wedding a few months later. The couple never had children. In order to support himself and his wife, Leighton left Maine and went to Rhode Island to work in the artistic furniture business, in which he was able to make quite a bit of money, enough to return to the work he loved: painting animals. Eventually, the Leightons moved to Boston where Scott's reputation as a painter of horses earned him the moniker of "Landseer of the United States." He had become one of the most famous painters of animals of his day. The titles of his best-known works bear witness to his love of animals, especially dogs and horses, as artistic subjects: *In the Stable*, *On the Road*, *The Pet*, *Dogs* and *The Fearnaught Stallions*. Leighton also painted other animals as central figures, including cattle (*In the Pool*) and a rooster (*In the Barn*).

Leighton's Lakes Region home called to him, although he had become a successful painter in Boston. Even though the Leightons owned a summer home in Claremont, New Hampshire, Scott and Sadie spent many summers

Nicholas Winfield Scott Leighton painting, "The Old Mare the Best Horse." *Library of Congress.*

at the Poland Spring Resort, staying in a tower room overlooking the Presidential Range and the many ponds dotting the resort property, which was owned by the Ricker family. According to an article in the *Lewiston Saturday Journal*, Leighton painted the canvas *A Morning Ride* for the Rickers. That painting was valued at $10,000 and displayed at the State of Maine Building at the World's Fair. The canvas hung at the resort for a time but was moved around from place to place on other Ricker properties before eventually being destroyed by fire. After that, Leighton painted another canvas for the Rickers, this time depicting the Poland Spring House in the distance, with a band of men and women riding to the hounds. The current owner of the resort, Cynthia Robbins, says they no longer own that painting.

And then Scott Leighton's world fell apart. The *Lewiston Saturday Journal* reported on January 5, 1898: "It will be a sad announcement to many friends of Scott Leighton, the eminent Boston artist, to know that on Monday, he was taken from his home at the Revere House in Boston to the McClean Asylum for the Insane at Waverly, Mass."

The article went on to give more details of the breakdown, noting that Leighton had begun to act queerly and was hallucinating that he had

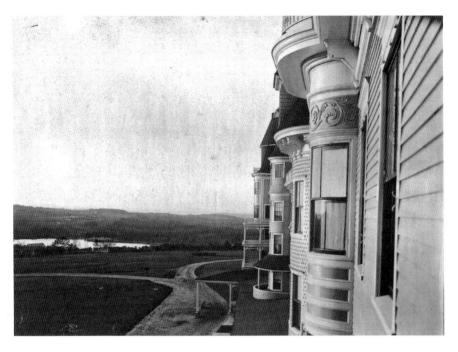

View of the golf course and lakes from a tower room of the Poland Spring Hotel. *Poland Historical Society.*

immense sums of money, which he must give away immediately. Apparently he created a scene in the hotel lobby, and "Dr. Jelly was called to examine him and pronounced him insane." Sadly, Scott Leighton never recovered, and he died at the McClean facility a few weeks later on January 18 from pneumonia, at age fifty.

LONGFELLOW'S SEBAGO LAKES REGION INSPIRATION

H enry Wadsworth Longfellow was perhaps America's most popular poet of the nineteenth century. He was born in Portland, Maine, on February 27, 1807. Some of Longfellow's most famous works include "Evangeline," "Song of Hiawatha" and "Paul Revere's Ride." In these works, lyric poems are the vehicles for historical stories and legends that captured the poet's imagination.

Longfellow had a very strong connection to the Sebago Lakes Region for several reasons. As a boy, Longfellow enjoyed fishing for salmon and sailing on Sebago Lake. In later life, when he was sixty-eight, Longfellow visited the Lakes Region on a family trip that included his brother Samuel and sister Anne, as well as the poet's daughters. The signatures of his party appear in the registry book of the Bridgton House, where they stayed overnight on September 14, 1875.

Longfellow had developed a literary plan to write a prose tale set in the Sebago Lakes Region. Although the prose project was never completed, Longfellow did compose and publish a poem about the Songo River, written in September 1875, after his visit with his family.

SONGO RIVER (excerpt)
Nowhere such a devious stream,
Save in fancy or in dream,
Winding slow through bush and brake,
Links together lake and lake.

Walled with woods or sandy shelf,
Ever doubling on itself
Flows the stream, so still and slow
That it hardly seems to flow.

Never errant knight of old,
Lost in woodland or on wold,
Such a winding path pursued
Through the sylvan solitude.

Never school-boy, in his quest
After hazel-nut or nest,
Through the forest in and out
Wandered loitering thus about.

In the mirror of its tide
Tangled thickets on each side
Hang inverted, and between
Floating cloud or sky serene.

Another connection to the region was Longfellow's friend, fellow writer and Bowdoin College (Brunswick, Maine) classmate Nathaniel Hawthorne, who spent part of his boyhood in Raymond and Casco, on the shores of Sebago Lake. They would remain friends after graduation. One day, when Longfellow and Hawthorne were at lunch with their friend Father Connolly of South Boston, the priest related an Acadian legend he had heard from a parishioner, and he suggested that Hawthorne write a novel about it. When Hawthorne seemed reluctant about the idea, Longfellow said to him, "If you don't want it, Nat, give it to me for a poem." This may have been the inspiration for *Evangeline*, Longfellow's first epic poem, published in 1847.

Longfellow and Hawthorne graduated in the Bowdoin class of 1825, along with their friend Horatio Bridge, who would later become the chief of the Bureau of Provisions for the U.S. Navy under President Franklin Pierce, yet another Bowdoin College classmate. Bridge would eventually author *The Personal Recollections of Nathaniel Hawthorne*, published in 1893. In this book, Bridge reminisces about Longfellow, who entered Bowdoin when he was just fourteen, along with his older brother Stephen. Bridge remembers the younger Longfellow as "frank, courteous, and affable,

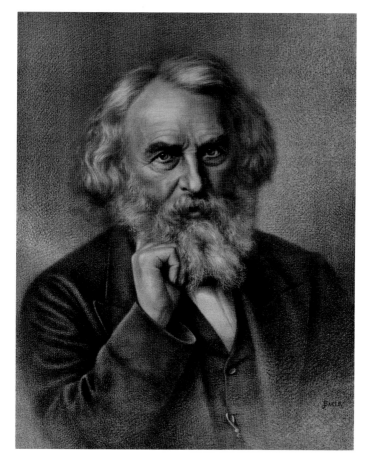

Portrait of Henry Wadsworth Longfellow. *Library of Congress.*

while morally he was proof against the temptations that beset lads on first leaving the salutary restraints of home. He was diligent, conscientious, and most attentive to all his college duties, whether in the recitation-room, the lecture-hall, or the chapel. The word 'student' best expresses his literary habit, and in his intercourse with all he was conspicuously the gentleman. His studious habits and attractive mien soon led the professors to receive him into their society almost as an equal, rather than as a pupil; but this did not prevent him from being most popular among the students. He had no enemy."

Bridge and Longfellow remained friends for more than half a century. In a December 12, 1875 letter to Bridge, the same year he wrote his poem about the Songo, Longfellow penned:

My Dear Bridge,

I have just had the pleasure of receiving your photograph. It is so good, it could hardly be better. I wish the one I send you in return were as good. But that is whishing [sic] that I were a handsome man, six feet high, and we all know the vanity of human wishes.

I was very glad that you and Mrs. Bridge were not disappointed in Songo River and its neighborhood. If Long Pond were called Loch Long, it would be a beautiful lake. This and Sebago are country cousins to the Westmoreland lakes in England, quite as lovely, but wanting a little more culture and good society.

I often think with great pleasure of our meeting at Brunswick. There was less sadness about it than I had thought there would be. The present always contrives to crown out the past and the future.

With kindest remembrances to Mrs. Bridge.

Always yours, Henry W. Longfellow

Longfellow's reference to Loch Long in the letter was to a poem by Samuel Rogers about a European lake. That poem was published in a volume of poetry edited by Longfellow and published in 1876. Long Pond (now called Long Lake) is between Naples, Bridgton and Harrison. In later years, a passenger steamer named after the famous poet navigated the Songo River. Longfellow was a professor at his alma mater, Bowdoin College, and, later, at Harvard. He died in 1882.

EDGAR WELCH, THE MAN WHO MOVED A MOUNTAIN

Edgar Welch was a bright, friendly man, though inclined to strange behaviors. For one thing, he was an addicted long-distance runner. When a running "spell" came over Edgar, he would abruptly stop whatever he was doing and run off. He was reported to have run long distances over ice in his stocking feet in winter, and in summer, he frequently ran barefoot. Upon his return, he would pick up whatever work he had left off.

On some occasions, he ran a 60-mile round trip from Casco to Portland, and once he reportedly ran to Boston, circled the Boston Common and then headed back home, a distance of 380 miles! Sometimes he was accompanied by his dog, Jip. On one of their runs to Mount Washington, Welch and his terrier became lost, and when Jip became exhausted, Welch picked him up and carried him until morning. Finally, they reached a farmhouse and Welch took Jip inside, but the dog died from exhaustion. When Welch's fame as a long-distance runner spread, he was invited to go to New York City to train for a marathon, but he did not like that metropolis, so he returned home before the race.

Historian Ernest H. Knight gives an account of Welch in his book *Historical Gems of Raymond and Casco*. A photo shows Edgar Welch in midstride, tall and broad shouldered, wearing a suit, boots and a tall beaver hat. This outfit was worn on Welch's run in 1899 through the White Mountains to the top of Mount Washington, which for many years was an annual trek. Knight states that this is the only known photo of the idiosyncratic Welch, but another photo of a much older Welch standing at the top of a mountain holding a

crowbar appeared in the February 25, 1939 edition of the *Lewiston Evening Journal*, thirty-six years after his death.

Welch was born in Raymond in 1849 and, as an adult, worked on a farm in East Raymond owned by David McClellan. The farm was adjacent to the eastern slope of Rattlesnake Mountain. While the mountain may have once been home to rattlesnakes, it is now home only to deer, chipmunks, raccoons and skunks. During Welch's time, Rattlesnake Mountain cast its shadows over McClellan's fields rather early in the evening, cutting short Welch's workday. Welch thought that if he could reduce the height of the mountain, it would allow more light to reach the farm in late day, and therefore he could get more work done. According to an article published in the *Lewiston Evening Journal* of February 25, 1939, "After working all day, Welch would climb Rattlesnake, which rises 1,046 feet above sea level, taking with him a lantern, a jack screw and a crowbar, and work the good part of the night prying off the peak." This work went on for nearly ten years.

Apparently the local citizens were often awakened at night by rumbling as the big boulders Welch pried loose came crashing down the mountain, taking down trees along the way. Welch did not blast the boulders and

View of Rattlesnake Mountain from the shore of Crescent Lake. *Author photo.*

used only his own labor to move them. According to the article, "This mountain-moving went on night after night, month after month, year after year, Winter and Summer. Probably Welch did pry off 1,000,000 cubic feet of Rattlesnake mountaintop." Some of this rubble can be seen today via a public hiking path accessed off Route 85. From the top of the mountain, on a clear day, you can see Sebago Lake, the Presidential Range, Panther Pond and Crescent Lake.

Among Welch's idiosyncrasies, his prodigious physical abilities and his apparent lack of a need to sleep, was the fact that Welch never seemed to perspire, even after running fifty or sixty miles in the heat of summer. This observation perplexed the medical community, who wondered why it did not bring on disease. But it never did, and Welch enjoyed good health his entire life, reportedly never even suffering from a head cold.

Welch had one more talent that baffled his friends even after he died. He was often heard to burst out saying "Eastman Bean, seldom seen," repeating the phrase over and over. Eastman Bean was a man who had lived in nearby Otisfield. Bean had tragically fallen from a haymow while holding a pitchfork, was impaled and died. Although this event had occurred when Welch was a young man, it must have made quite an impression. On December 23, 1903, at the age of fifty-four, Welch himself fell upon the tines of a pitchfork and died in exactly the same way as Bean. Clairvoyance or coincidence?

Edgar Welch's funeral was held at the schoolhouse in Webbs Mills, which was filled to overflowing. As odd as he was, Edgar Welch was a man with many friends.

HENRY CLAY BARNABEE, RENOWNED COMEDIAN

He could sing. He could dance. He could act. He could make people laugh. William Clay Barnabee, born in 1833, was considered one of the nation's funniest comedians of his day in the late nineteenth and early twentieth centuries. Barnabee was most famous for his performance of the Sheriff of Nottingham in the comic opera *Robin Hood*, a role he claimed to have performed nearly 1,900 times. It is difficult for us to imagine today the immense popularity of live comic opera stage performances, accustomed as we are to modern cinema and television sitcoms.

Barnabee was raised in nearby Portsmouth, New Hampshire, a state that boasts its own beautiful lakes district. In spite of that fact, apparently Barnabee enjoyed several summers in the Sebago Lakes Region. Walter Emerson, writing about Highland Lake and Bridgton, claimed that for many summers, Barnabee brought his opera singers "to these waters for rest and recuperation and all the other joys of out-door life." Emerson remembers, "How they made the woodlands ring! I can hear even now, echoing up and down the lake, the grand bass of Gene Cowles in his "Will Scarlet" songs. I can see Friar Frothingham stirring a pot of white perch chowder." Curiously, Barnabee makes no mention of these gatherings in his 461-page autobiography, an interesting blend of prose, verse and testimonials from friends and acquaintances. A full text of the autobiography is available online.

Barnabee fell in love with and married Clara George, to whom he would be married fifty years. The actor helped to organize the production company known as the Bostonians, which performed all over the country

Photo of Olive Fremstad, who summered on Highland Lake in the early twentieth century. *Library of Congress.*

and abroad. According to Ned Allen's *Images of America: Bridgton*, the Bostonians performed annually in Bridgton for a number of years. Another famous opera star, Metropolitan soprano Olive Fremstad, enjoyed respite on Highland Lake. She built a summer house on the shore of the lake in 1914, which she named Nawandyn. Fremstad and other nationally known performers appeared at the Saco Valley Music Festival, held annually at the Bridgton Town Hall.

Barnabee began his stage career in 1865 in Boston, the same year that President Lincoln was assassinated by actor John Wilkes Booth at Ford's Theatre in Washington. In his heyday, Barnabee was a stage contemporary of the Shakespearian tragedy actor Edwin Booth, one of the most famous actors of his time. Edwin was the brother of President Lincoln's assassin, John Wilkes Booth, also an actor. In fact, Barnabee considered himself the comic equivalent of the tragedian Edwin Booth. In his autobiography, Barnabee notes that he and Edwin were born just a day apart in 1833, "an exemplification of the fact that Mirth follows close on the heels of Tragedy." The *New York Times* would later use the quote in Barnabee's obituary. Barnabee makes much of his connection to Edwin Booth in his autobiography. He claims that on his very first visit to the theater, Barnabee saw Edwin's father, actor Junius Brutus Booth, play the part of Brutus in the tragedy of that same name. Coincidentally, Edwin made his first stage appearance at that same performance.

The actor genuinely enjoyed his acting career, especially the applause he received after a great performance. "I must say I like it," he admitted. "There is nothing sweeter than the rippling of the impact of dainty gloved hands and the more sonorous reverberations of the hardened palms of men. It proves to the actor that he has made a place for himself in the affectionate regard of the great mass of human beings known as the Public."

Barnabee's stage career lasted until 1909, the same year in which his beloved wife, Clara, died on Christmas Day. He died in 1917 at age eighty-four and is buried in Portsmouth, New Hampshire. Barnabee's collection of scrapbooks, photographs, music scores, souvenir books and watercolors are in Special Collections at the Portsmouth Public Library. Although New Hampshire claims Henry Clay Barnabee as her native son, apparently the actor frequently found rest and renewal in the Sebago Lakes Region of Maine.

WALTER GIBSON, THE SHADOW KNOWS

"Who knows what evil lurks in the hearts of men? The Shadow knows!"
(Sinister laugh)

Just about anyone over the age of fifty knows that this line introduced an episode of the popular radio series *The Shadow*. The Shadow character was the brainchild of puzzle creator, magician and writer Walter B. Gibson (1897–1985), using the pen name of Maxwell Grant. Creation of the Shadow stories has a strong Maine connection. In fact, many of the *Shadow Magazine* print novels were written at Gibson's Little Sebago Lake cabin in Gray at a desk made of sturdy Maine pine. At least three of his stories were set in Maine: *The Isle of Gold* (August 1, 1939), *Vengeance Bay* (May 1, 1942) and *Crime Over Casco* (April 1946). Gibson created one final Shadow story set in Maine for the *Duende History of the Shadow Magazine* in 1980, the fiftieth anniversary of the Shadow's debut on radio. In the story "Blackmail Bay," the Shadow tries to unmask a blackmailer on fictional Spruce Island in the Cobosco Bay off the Maine coast. Clues are everywhere, as are all the traditional Shadow story elements—a mysterious disguise, a secret code and the use of the "devil's whisper," a substance used to create an explosion of light and sound with the snap of the fingers.

According to Gibson's biographer Thomas Shimeld, Gibson was a prolific writer who authored 187 books, 668 periodical articles, 283 full-length novels for the *Shadow Magazine*, 48 separate syndicated feature columns and 149 scripts for *Shadow Comics*. In addition, he helped to develop the character for

radio scripts and contributed Shadow adventures to hundreds of newspaper comic strips. According to Shimeld, Gibson did not consider the radio version of his Shadow character to be the same as the print character he created, but the radio broadcasts, which Gibson did not write, aided in the popularity of the print character nonetheless.

The Shadow, first created by Gibson in 1930, was a mysterious character whose face was partially obscured by a wide-brimmed black hat. Dressed in black pants and cloak, he fought evil mobsters and dangerous foreign invaders and saved helpless victims. At the end of each radio episode, the narrator Shadow reminds listeners that "crime does not pay…the Shadow knows!" (followed by the sinister laugh). In the print version, Gibson's prose style engages all the reader's senses, and here the Shadow also gets the last laugh.

In Gibson's stories, the Shadow often assumes other identities as a disguise, much as Superman, another double-identity superhero, takes the identity of Clark Kent. The best-known Shadow identity is that of Lamont Cranston, a wealthy man about town whose love interest is Margo Lane. Gibson's friend and eulogist William Rauscher called Gibson "the Wizard of Words" and described the chain-smoking author as prophetic in his storytelling. For his Shadow stories, Gibson created, among other things, robot masterminds and suction cups for scaling walls. The Shadow's alter ego Lamont Cranston traveled in an autogiro, a predecessor of the modern helicopter, and used searchlights that projected darkness rather than light. In the Shadow's house, there was a remote radio system resembling an early example of a digital clock. The Shadow also had the ability to become invisible. Gibson created a legend in the Shadow and, by doing so, became a legend himself.

The great magician and escape artist Harry Houdini befriended Gibson in the early 1920s. Later, he asked Gibson to ghostwrite for him a series of books exposing the secrets of magic. Gibson completed the first of the series, but then Houdini died so Gibson published the book under his own name.

Gibson's Maine connection began at an early age. His mother had grown up in Calais, Maine, and Gibson as a boy had visited his relatives there and spent summers at boys' camps around the Rangeley Lakes and Casco Bay of Maine. In 1934, Gibson and his second wife, Julia Helen Martin, began vacationing in Maine. His cousin, Carlton Eaton, lived on Little Sebago Lake in the small town of Gray, and Gibson was able to buy the land adjacent to his relative. Maine would be a good place to get away from the hectic life he lived in New York, thought Gibson. It would be an ideal place to write, away from the hubbub of the city. His new wife agreed, so the Gibsons

Old postcard view of Little Sebago Lake taken from shore, postmarked 1913. *Linda Markee collection.*

began construction of a log cabin in the summer of 1936. In part, he built the cabin in order to spend more quality time with his young son, Robert, from his first marriage.

The first summer, Gibson arrived so early in the season that the cabin was not quite finished, so he reportedly worked on his Shadow manuscripts while the carpenters continued the construction around him. Gibson designed a desk for the cabin, which the carpenters made from Maine pine scrap, its top just big enough to hold his Corona typewriter. The desk had a box on the left side into which Gibson dropped his finished pages. Also on the side of the desk were slots for storing blank paper and carbons. He sat in a solid oak swivel chair as he worked at this desk. (The desk and typewriter, along with a photograph of Gibson, sold for $4,510 at an auction in Kingston, New York, in 1996, and the chair sold for $385.)

While he lived in Gray, Gibson's Shadow story output for the Street & Smith Publication Company was nothing less than phenomenal. The *Shadow Magazine* was published twice a month, on the second and fourth Fridays. In 1936, a yearly subscription cost two dollars; six months, one dollar; a single copy, ten cents, and Gibson, writing as Maxwell Grant, wrote all of the Shadow adventures for this publication. One headline summarized his productivity by proclaiming, "A Million Words a Year for Ten Straight Years."

Gibson claimed that he often got his story ideas in mysterious and unexplained ways, ideas that he said he picked up psychically. For example, Gibson once wrote a story set in Maine about a group of people, including a sheriff, who were trapped together in a building. One by one, the people were murdered, and at the end of the story, the reader discovered it was the sheriff who was the killer. In a 1945 newspaper article, Gibson explained: "I had picked the locale as a place in Maine I was familiar with. Quite a long time afterward, I was in that town and learned that the local sheriff had, indeed, been arrested and convicted of a crime."

At his lake cabin, Gibson worked in a central room with a vaulted ceiling. He refused to have a telephone. To maintain his writing privacy and to accommodate family guests, Gibson erected a number of eight-foot by ten-foot tents for sleeping quarters. But cold weather comes early in Maine, so in the fall of 1936, Gibson and Julia purchased a house in Gray village, about five miles away from the cabin. This house still stands on the corner of Shaker Road and Gray Park. When the Gibsons lived there, they became favorites of the Gray citizens, and Gibson and his son, Robert, would reportedly sometimes entertain visitors with card tricks and other magic exchanges. Audrey Burns, a member of the Gray Historical Society, grew up in a house across the street from the Gibson house. She remembers that one of the rooms in the house, the one in which Gibson stored his magic tools, was painted silver. She and some of the other children in the village were a little frightened of Gibson.

By 1946, Gibson's second wife, Julia, had left him, and in 1948, she signed a quitclaim on the deed to the Little Sebago Lake cabin. Interest in the *Shadow Magazine* was fading, but Gibson continued to write, mostly about mental magic, psychic phenomena and true crime. He married again in 1949 to magician Litzka Raymond, and the shared love of magic bonded the couple's marriage, but it seems Gibson's connection to Maine was finished. Gibson continued to write until the end of his life, and the Shadow projects continued to consume some of his time.

The Shadow character copyright and trademark were acquired by Conde Nast Publications in 1973, which gave Gibson 50 percent of the reprint royalties for the Shadow. Later, in 1976, Gibson got a contract from Harcourt, Brace Jovanovich for a history of the Shadow character, titled *The Shadow Scrapbook*, published in 1979 when Gibson was in his eighties. He also worked on other Shadow projects, including a game and a movie script, and he began to write a new Shadow novel, but on December 6, 1985, Gibson died after completing just a few chapters and before the movie could be

produced. He is buried in Kingston, New York. In 1994, a film version of *The Shadow*, starring Alec Baldwin, debuted but was a bomb at the box office.

The Shadow's popularity appears to be timeless, at least for collectors. A January 1, 1933 edition of the *Shadow Magazine* on eBay recently listed for sale at $500. What is the secret to the Shadow's long-lived intrigue for readers, listeners and viewers? The Shadow knows. And so did Walter B. Gibson.

ALFRED NORTH WHITEHEAD, FAMOUS PHILOSOPHER, FINDS RESPITE ON LITTLE SEBAGO

"I think it is a mistake to cling to a region because it has given you a delightful experience once. You merely accumulate dead possessions. Don't cling to the old because it made you glad once: go on to the next, the next region, the next experience."
—*Alfred North Whitehead*

S pending time at a tranquil Sebago Lakes Region summer camp is respite for any soul. For the intellectual, it is also respite for the mind. At least that was true for Alfred North Whitehead, who liked to sojourn at his son's cottage on Battleship Island in Little Sebago Lake.

Whitehead (1861–1947) was a British mathematician who became an American philosopher. He married Evelyn Wade in 1890, and they had three children: two boys and a girl (one son, Eric, was killed in World War I). Whitehead may be most famous for his influential work *Principia Mathematica*, a three-volume work he coauthored with philosopher and mathematician Bertrand Russell. After Whitehead's career in mathematics in Britain ended, Whitehead turned his attention to the study of philosophy. In 1924, he was invited to become professor of philosophy at Harvard University in Cambridge, Massachusetts. The Whiteheads left their native Britain to live in America and spent the rest of their lives here. Whitehead was to become a pioneer in the approach to metaphysics known as "process philosophy."

After Professor Whitehead's retirement from Harvard in 1937 at age seventy-six, the couple made their permanent home in an apartment in the

Hotel Ambassador in Cambridge, Massachusetts, but they needed a place to go in the summer to get out of the heat. The Whiteheads purchased Battleship Island in 1936, according to a *Lewiston Sun Journal* article. The tiny island, still privately owned, is big enough for a single camp. At some point, the Whiteheads' son Thomas must have acquired the Battleship Island property because a *Lewiston Sun Journal* article for July 2, 1945, notes, "Prof and Mrs. Alfred Whitehead of Cambridge, Mass., are spending six weeks with their son, at his cottage on Little Sebago Lake. Professor North Whitehead is at the lake for two weeks' vacation and Mrs. Whitehead is spending the summer there." Their son, a mechanical engineer, was then on the faculty of the Harvard School of Business Administration.

Whitehead remained intellectually active into his eighties and continued to go to Maine for part of each summer. He continued to write, and his wife was his editor and guardian of his health. Their friend, philosopher Lucien Price, remembers a conversation with the Whiteheads on June 19, 1945:

> *They said they were off to Maine on Friday.*
> *"What is your address?"*
> *"Battleship Island, Little Sebago Lake, West Gray," said Mrs. Whitehead.*
> *"The island is about a quarter of an acre. It has the great advantage," she glanced sidewise at Alfred, "that one cannot go on too long walks."*

On old maps, Battleship Island is called Little Crow, but the Whiteheads renamed it after Thomas built the cabin, which resembles a battleship, according to GiGi Elliott, a former owner. She thinks that Thomas designed the building that way because he once served in the British Navy. The original cabin is still there today and pretty much covers the landmass that supports it. The doorknobs are hand carved, and some of the furniture was handcrafted by Thomas Whitehead, said Elliott.

Alfred North Whitehead's published works include such titles as *The Concept of Nature*, *Religion in the Making*, *Science in the Modern World* and *Adventures of Ideas*. Though the titles may seem simple and straightforward enough, the subject matter is difficult. In fact, one Whitehead biographer noted that Professor Whitehead's book *Process and Reality* was "easily one of the most difficult books in the entire Western philosophical canon."

While Alfred North Whitehead's teachings may seem complicated and controversial to the untrained mind, his work was influential among scholars in his field. His lectures were often quoted, and you can find lists of his pithy sayings on more than one internet site.

Little Sebago Lake perspective from a kayak. *Deb Gellerson photo.*

Whitehead suffered a stroke on Christmas Day in 1947 and died a few days later at age eighty-six. His body was cremated, and there was no funeral. His unpublished manuscripts were destroyed according to his wishes. His *Times* obituary stated, "Whitehouse invented a whole new vocabulary for the expression of his philosophic ideas. His terms, often based on etymology, are generally admirable but their novelty adds to the difficulty of his writings. No man ever clothed such profound thoughts in such obscure language."

It is supremely ironic that Whitehead's summer solace was an island location. Whitehead's philosophy asserted that no entity, nor any man, is an island, and every time we move, or think, we disturb the whole universe.

Part III

RUMORS AND MYSTERIES

GET OUT YOUR SHOVEL FOR BURIED TREASURE!

An exhibit in the Raymond Casco Historical Museum displays a gold-link chain next to a small sign that says the chain is "similar to necklace made from gold mined at the Symonds farm." According to information on a Raymond, Maine website, there was once a working gold mine located on what is now private land in Raymond. Volunteer workers at the historical museum said that the Symonds family no longer owns the property, but the current owners found what they believe is a slave cuff inside the old mine. Does that mean that, years ago, slave labor may have been used to extract the metal? It does seem somewhat unlikely, and definitely illegal, since Massachusetts, of which Maine was then a part, abolished slavery in 1783.

Maine has never been a major mining region for gold or silver. Nevertheless, a few localities in Maine have yielded some gemstones and small amounts of precious metal. Recreational prospectors have found gold in the Swift River near Byron, and a coastal construction company once uncovered a small amount of gold near Ogunquit. Gold has also been found in areas north and east of Rumford. But according to Raymond Historical Society president Wayne Holmquist, there just wasn't enough gold in the Raymond mine to continue digging.

The Symonds farm gold mine may be defunct, but that doesn't mean there is no gold to be found today in the Sebago Lakes Region. Consider the legend of a bag of stolen gold buried in Raymond by two bank robbers in the early nineteenth century. According to the story, related in some detail and with quite a bit of speculation from Ernest H. Knight in *Historical Gems of*

Raymond and Casco (Chapter 9), the robbery of $200,000 from the Cumberland Bank in Portland occurred on Saturday, August 1, 1818. This was Portland's first bank robbery. The robbers, Daniel Manley and Benjamin Rolfe, were apprehended the following Wednesday. Rolfe, a sail maker, committed suicide on Thursday, August 6, after being unable to find the loot, which he said Manley had stuffed into sailcloth bags and buried near the Portland waterfront. Did Rolfe kill himself in anguish over not being able to find the buried money? Or did he do it in remorse over the crime? Manley spent twelve years in a Boston prison for the crime, and when he died in 1837, he was buried in Eastern Cemetery in Portland, his gravestone inscribed with "Portland's First Bank Robber—1818."

Most of the money was eventually recovered from its burial place near a hedge fence in Scarborough, but according to one account, not all of the loot was found. Did Rolfe bury part of the bank loot on family property in the Sebago Lakes Region thirty miles away sometime during the three days between the robbery and his capture? There is a legend concerning buried treasure connected to a property in Raymond that once belonged to relatives of Benjamin Rolfe. According to Knight's account, a later resident of the house once went to a spiritual medium to ask the whereabouts of the buried treasure. The medium answered that "she was walking on it." The basement of the house was a maze of walls and foundations that could easily hide the stolen treasure. No one ever reported finding the bag of gold.

Nathaniel Hawthorne's Lost Boyhood Diary

In 1897, Houghton, Mifflin and Company published a small book titled *Hawthorne's First Diary, With an Account of its Discovery and Loss*, edited by Samuel T. Pickard. From the beginning, the publication sparked a controversy.

Young Nat Hathorne (he would later change the spelling of his name to Hawthorne) loved to spend his boyhood days roaming the forests of Raymond, Maine, and swimming and fishing in nearby Dingley Brook and Thomas Pond. The flat rock visible in that pond still bears his name. In the winter, Nat liked to skate on Sebago Lake, whose shores were adjacent to his house. Hathorne, of course, would grow up to pen such acclaimed works as *The Scarlet Letter* (1850), *The House of the Seven Gables* (1851) and *The Marble Faun* (1860), and some have speculated that he may have been inspired to write these stories by his acquaintances and experiences as a boy in Maine.

Nat's widowed mother, Elizabeth Hathorne, had moved from Salem, Massachusetts, to Raymond with her three young children sometime between 1813 and 1815, to live in a house built for her by her brother Robert Manning. Another brother, Richard Manning, and his wife, Susan Dingley Manning, lived just across the street from the Hathornes. The Mannings owned stage lines and livery stables in Salem, and they had inherited twelve thousand acres in Raymond (Maine had not yet become a state) from their father.

Both houses still exist. The Manning house, built in 1810, known as Manning's Folly, is now a private residence sitting just across the line from Raymond in Casco. It has eight fireplaces and walls papered with imported

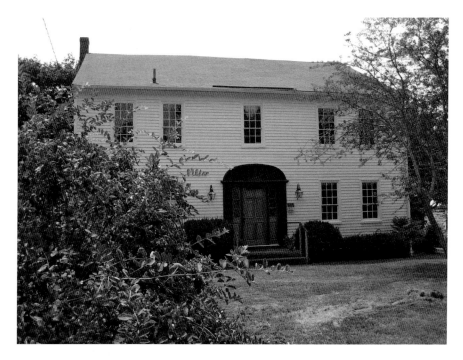

Photo of the Hawthorne house in Raymond, Maine. *Author photo.*

European wallpaper. Windows over the front door are made of Belgian glass. The house must have seemed like a palace to the local citizens of Raymond, which was then still a wilderness. The Hathorne family lived in this house with the Mannings while their own house was being built. The Hathorne house has since been restored and is now used to host community events, but it was in this house that the diary, if it is authentic, would probably have been written.

According to Pickard, the diary's publisher and editor, when Nathaniel's mother left this house in 1822 to return to Salem, her furniture included a bookcase that housed the diary. The bookcase containing the diary was moved across the street to the Manning house two years later. The story of how this diary made it into Pickard's hands is complicated.

According to Pickard, "This book was originally a bound blank one, not ruled, and has been gnawed by mice or eaten by moths on the edges. On the first leaf, in a beautiful round hand, is written the following:—'Presented by Richard Manning, to his nephew, Nathaniel Hawthorne, with the advice that he write out his thoughts, some every day, in as good words as he can, upon any and all subjects, as it is one of the best means of his

securing for mature years, command of thought and language. Raymond, July 1, 1816.'"

Pickard says the diary surfaced in Virginia during the late Civil War through a boyhood acquaintance of Hawthorne's named William Symmes. Symmes had been given the diary by a soldier from the Twenty-fifth Maine, named Small, who had lived in Raymond and claimed to have moved Mrs. Hathorne's bookcase to the Manning residence in 1824. For some reason, Small had taken the diary, and later he sent it to Symmes, who in turn contacted Pickard by letter in 1870 and told him about the diary. According to Pickard, Symmes copied excerpts of the diary and sent them to Pickard, who published them in three installments in 1871 and 1873. Later, says Pickard, Symmes sent the diary itself. Twenty-six years later, in 1897, Pickard published the diary in book form, titled *Hawthorne's First Diary, With an Account of Its Discovery and Loss*. Why did he wait so long? Was it because he was composing the diary himself, as some scholars believe?

The writer of the diary tells about sailing on Sebago Lake and describes the cave at Frye's Leap, also known as the "Images" because of the pictorials drawn on the cliff walls by the Native Americans. The diary writer is a keen observer of nature and provides descriptions of kingbirds, bear, an eel and rattlesnakes. One of the excerpts is a description of the burial of the Tarbox couple who died in a blizzard on Raymond Cape (see Chapter 21 for this account). The excerpts include the names of people then living in the Sebago Lakes Region, as well as place names, all of which Hawthorne would have known as a boy.

One of the most interesting accounts in the diary is a story about a talking horse that is beaten by his master. A boy takes pity on the horse and feeds it some corn: "At last the horse winked and stuck out his upper lip ever so far, and then said, 'The last kernel is gone'; then he laughed a little, then shook one ear, then the other, then shut his eyes as if to take a nap. I jumped up and said, 'How do you feel, old fellow; any better?' He opened his eyes, and, looking at me kindly, answered, 'Very much,' and then blew his nose exceedingly loud, but he did not wipe it; perhaps he had no wiper."

The boy then finds the cruel master's whipping stick and destroys it, and at the end of the story, the horse walks away. Pickard notes at the end of this excerpt that Hawthorne's son-in-law and biographer, George Parsons Lathrop, says the horse story might be the first recorded instance of Hawthorne as a writer of fiction.

Scholars doubtful of the diary's authenticity claim that the prose style of the passages in the diary are too mature to be written by a teenager (if

it is authentic, young Hathorne would have written the passages between the ages of twelve and fifteen). External evidence against its authenticity concerns the chronology of the events related in the diary. First is the account of a drowning incident. The diarist writes, "A young man named Henry Jackson Jr. was drowned two days ago, up in Crooked River." Actually, the Jackson drowning was documented as having taken place in 1828, not when Hathorne was a boy, but when he was twenty-four and long gone from Maine. A second piece of evidence against authenticity of the diary concerns the spelling of the Hawthorne name. The inscription is to Nathaniel Hawthorne. Pickard claims that Nathaniel changed the spelling of his name from Hathorne to Hawthorne while he was a boy, but scholars claim he did not change the spelling until he was a student at Bowdoin College some years later. Nathaniel's mother went by the name of Hathorne all her life, though the diary refers to her as Mrs. Hawthorne.

Why would Pickard fake such a diary? Pickard was himself a writer of some talent and had published a book-length biography of the poet John Greenleaf Whittier in 1894. Pickard would certainly have had the editorial skills to pull off such a hoax. Historian Edward Little enumerates four other motives that may have caused Pickard to fabricate the diary: "1. Pickard's genuine respect for Hawthorne the writer and a desire to connect his formative years with the State of Maine; 2. Pickard's professed desire to preserve the Manning house in Raymond as a literary shrine, though he never saw the project through; 3. Pickard's connection to Bowdoin, Hawthorne's alma mater, and his gratitude for the honorary degree he (Pickard) had received three years earlier and; 4. Pickard's apparent need to earn some money." Little also suggests that maybe, just maybe, Pickard found some humor and satisfaction in trying to fool the experts.

In 1901, Pickard published "Is Hawthorne's First Diary a Forgery?" in the *Dial,* in which Pickard concluded that Symmes was the forger of the diary, yet he wrote it in such a way as to make the reader of the retraction doubtful: "If Symmes wrote it, and I see no escape from this alternative, it was done when he was nearly seventy years of age, after a strenuous life as a cook on a sailing vessel, and as a spy on spies during the Civil War. It must have required the genius of a Chatterton to have forged that story in language so like what Hawthorne would use."

Julian Hawthorne, Nathaniel's son, claimed that the diary was a hoax, but his sister Elizabeth, called Ebe, was not so sure. The diary contains too many details of Raymond life that can be documented as authentic. Brenda Wineapple, a recent Hawthorne biographer, wrote, "We, like Ebe, can't

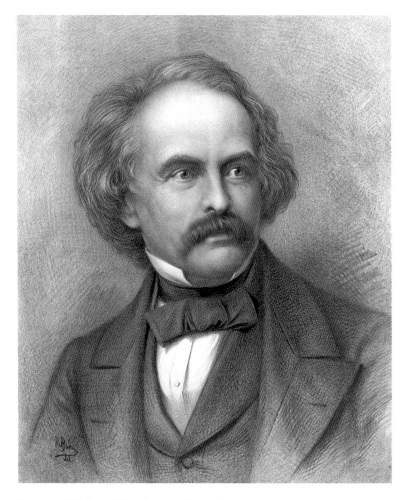

Portrait of Nathaniel Hawthorne. *Library of Congress.*

discard it [the diary] out of hand. If not by Hawthorne himself, the passages were written by someone who knew him and his family." Reportedly, Pickard and Hawthorne never met, but young Nat most certainly had known Symmes as a boy growing up in Raymond.

Was Nathaniel Hawthorne's (1804–64) boyhood diary authentic, or was it a deliberately fabricated text masquerading as real? And if it was a forgery, who wrote it—Pickard or Symmes, or someone else?

THE LOST FOUNTAIN STONE OF THE SABBATHDAY LAKE SHAKERS

The grounds are peaceful and beautiful, especially in the summer, and the buildings are well maintained and inviting. It is almost breathtaking when the village comes into sight as one crests the hill in this rural part of Maine, less than an hour's drive from busy Portland.

Beyond the fenced-in sheep pasture, visitors to the 1,800-acre farm can see Sabbathday Lake itself glittering in the distance. Across the road, on a hill behind the meetinghouse and library, is an orchard. Sabbathday Lake Shaker village in New Gloucester is the only place in the world where you can visit with living Shakers and attend a Shaker religious service. Founded in 1783, the Shaker village is located off Route 26 in New Gloucester. It is the sole active remaining Shaker village today, with just 3 members. At its peak in 1784, it was home to 187 members. Today, the village includes an active farm, a museum, two gift shops and a library. Some of the buildings are open to the public seasonally. (Check the Sabbathday Shaker Village website for directions and hours of operation.)

The Shakers (United Society of Believers in Christ's Second Appearing) are characterized by their communal and celibate lifestyle that embraces pacifism and equality of the sexes. Historically, the Shaker culture is known for its rich collection of music, as well as its distinctive and simple style of handmade furniture.

Like many other religions, Shaker history includes periods of revival, times of extreme rituals, mysticism and reawakening. In 1842, an edict from the Shaker elders went out to the eighteen Shaker communities requesting

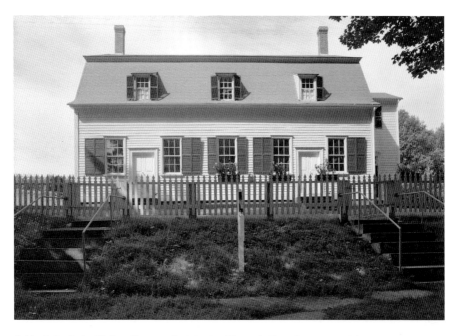

Sabbathday Lake Shaker Community Meeting House in New Gloucester. *Library of Congress.*

Interior of Sabbathday Meeting House. *Library of Congress.*

that they hold a religious service twice a year (May and September) on the highest point of land, known as a holy mount, closest to their settlements. The Shakers at Sabbathday and at all the other Shaker communities (at that time they were located in Maine, Massachusetts, Connecticut, New Hampshire, New York, Ohio and Kentucky) cleared, leveled and enclosed their holy spots. At the Sabbathday Lake community, the feast ground was created in 1844 and known as Mount Hermon. It was located near the present-day orchard. The Shakers also built a "storm house" to use in case of inclement weather. The Shakers designed their feast grounds in this way: an inner hexagonal plot called the "fountain" was surrounded by a low fence and marked with an inscribed marble slab, known as a fountain stone or the Lord's Stone. These stones marked the spots where the spiritual waters flowed from heaven to earth, and worshippers could bathe in this "water" to wash away sin and be renewed. Reportedly, the stones were inscribed with verses received by divine inspiration. At least one was inscribed with a warning to any who might desecrate the holy feast grounds, but we cannot know that this was typical for all the stones because only one has survived.

In these sacred spots, new rituals were introduced into the worship of the Shakers, who claimed that they received visits and messages from the dead of many nations, including biblical and historic persons: Tecumseh, Noah, Napoleon, George Washington and others. Even Jesus was reported to be "at home" in the Shaker village at North Union, Ohio. Some of the Shaker mediums, called "instruments," received messages from departed Shakers, including the religion's founder, Mother Ann (1736–84), calling them to return to the roots of the faith. There was much marching, singing and dancing.

As the intensity of the rituals increased, the worship meetings on the Sabbath were closed to the public to discourage curious outside spectators who had heard about the peculiar goings on. On an American tour in 1842, the English novelist Charles Dickens journeyed to New Lebanon, New York, to visit the Shaker village there. He was turned away. In the same year, the American writers Ralph Waldo Emerson and Nathaniel Hawthorne visited together the Shaker village near Harvard. Hawthorne had spent part of his boyhood growing up in Raymond, Maine, just a few miles away from the Sabbathday Lake Shaker Village. As a young man, he had once considered joining the society. He wrote in his journal, "I spoke to them about becoming a member of their society, but have come to no decision on that point." Hawthorne would visit the Shakers again in 1851 with his friend Herman Melville. Hawthorne wrote two short stories about the Shakers, both melancholy tales: "The Canterbury Pilgrims" and "A Shaker Bridal."

The period of Shaker revival, known as the Era of Manifestations or Era of Mother's Work, lasted about ten years, and when the feast grounds were no longer used for worship meetings, some of the Shaker communities broke up or buried their fountain stones. Shaker scholar Stephen J. Paterwic notes that, incredibly, a few of these stones remained intact and undefiled in their abandonment for over fifty years before the Shakers had them buried in preparation for selling their property. Of course, most of the people who buried the fountain stones are now gone, and according to Paterwic, amateur efforts to locate the stones have not been successful.

The one surviving fountain stone is from the Groveland, New York Shaker Community. It was at first believed to be lost but then was found buried in the basement of the former dwelling house of the Groveland Shaker Community in Livingston County. It is on exhibit at the New York State Museum in Albany. The fountain stone was engraved by Isaac N. Youngs and erected at Groveland on May 18, 1843.

The inscription reads:

THE WORD OF THE LORD
Hearken, O ye children of men, to this,
The word of the Lord your God; yea, read, under
Stand and give heed to the same, For with the finger
Of my hand have I written it, and at my word
Was it engraved on this stone, which I have caused
To be erected here, and called by my name
THE LORD'S STONE
Thus saith Jehova, Behold! Here have I opened
A living fountain of holy and eternal waters, for
The healing of the nations.
Here have I chosen a sacred spot, and
Commanded my people to consecrate and
Sanctify it unto me their Holy God.
Here shall my name be owned, feared and
Praised; and I alone will be adored by the nations
Of the earth; and unborn millions that shall pass
This way, shall bow in reverence to this, the work
Of my hands, saith the Holy One of Israel,
The Great I AM, the Almighty Power.
Therefore, let the stranger from afar, and the
Traveler, behold this work with sacred reverence,

And pass by in the solemn fear of his God. And let
None presume to trifle with this my work. Lest in my
fierce anger I stretch forth my hand against them.
For whosoever shall step upon this my holy
Ground, or lay their hands on this stone with
Intent to do evil, or to injure it in any way,
Shall in no wise escape the justice of my
Righteous power. And in my own time will
I, even I, bring an awful curse upon them,
Saith the Eternal Judge of all and the
Overruling Power of Heaven and Earth,
Whose word is truth. Amen.

Not much remains today of the Sabbathday Lake sacred worship spot. The storm house was relocated to another area and used by the Shakers as a tool shed. In the 1890s, gypsies burned down the building after the Shakers denied them handouts. The hill, Mount Hermon, was plowed over in the 1890s when a commercial orchard was planted. Today, it is still an orchard. No one knows what was inscribed on the Sabbathday Lake fountain stone. That the community had a fountain stone is certain, and it is mentioned in *Creating Chosen Land: Our Home from 1783–2010*, a museum gallery guide prepared by Brother Arnold Hadd, one of the three remaining Shakers living at Sabbathday Lake. Brother Arnold said that the fountain stone was destroyed. Are the pieces buried somewhere, waiting to be unearthed one day and displayed to the living?

THE UNDERGROUND RAILROAD IN THE SEBAGO LAKES REGION

Before the Civil War, the Underground Railroad extended through fourteen states. Of course, there was no literal railroad that ran underground. Although some of the fugitive slaves did make their way north to freedom by rail, many others traveled by water or overland routes. The language that evolved around the Underground Railroad became code for the escape process. Stopping places for safe shelter were called "stations," and people who conducted the fugitives from station to station were called "conductors." Fugitives were called "baggage" or "freight"; and an "agent" or "ticket master" was the person who plotted the escape route.

Participating in Underground Railroad activity was dangerous for everyone involved. Under the Fugitive Slave Act of 1850, law enforcement officials were penalized and fined if they did not arrest and return a suspected fugitive. Suspected slaves could not appeal for a trial, which resulted in many free blacks being kidnapped into slavery. Additionally, any citizen caught aiding a fugitive by giving food or shelter could be fined $1,000 (about $28,000 by today's standard) and sentenced to six months in prison.

It should come as no surprise that fugitives from the southern states frequently traveled through the Sebago Lakes Region on their way to freedom in Canada. According to Wilbur Seibert, a nineteenth-century Ohio scholar whose specialty was Underground Railroad history, escaping slaves sometimes reached Portland, Maine, traveling as stowaways on ships. After they disembarked on the Maine State Pier, they walked up India Street onto Newbury Street to the Abyssinian Meeting House in search of help.

Cartoon satire of the Fugitive Slave Law. William Lloyd Garrison is depicted defending a slave woman from authorities. *Library of Congress.*

The Abyssinian is currently undergoing preservation work and is the third-oldest standing African American meetinghouse in the country. William Lloyd Garrison and, perhaps, Frederick Douglass gave speeches there.

Portland was a hotbed of abolitionist activity before the Civil War, and its citizens, both white and black, were active in aiding escaping fugitives. One

THE FUGITIVE SLAVE LAW.

Underground Railroad conductor, Reuben Ruby, a free black, owned a hack business in Portland, and his vehicles were sometimes used to transport men, women and children fleeing to safety. Another well-known white abolitionist was Major General Samuel Fessenden, a prominent lawyer known to have harbored many fugitives in his own home. His son, William Pitt Fessenden, was a Maine legislator, member of the U.S. House of Representatives and a Maine senator during the Civil War era. The younger Fessenden also opposed slavery, though he was not the radical abolitionist his father was.

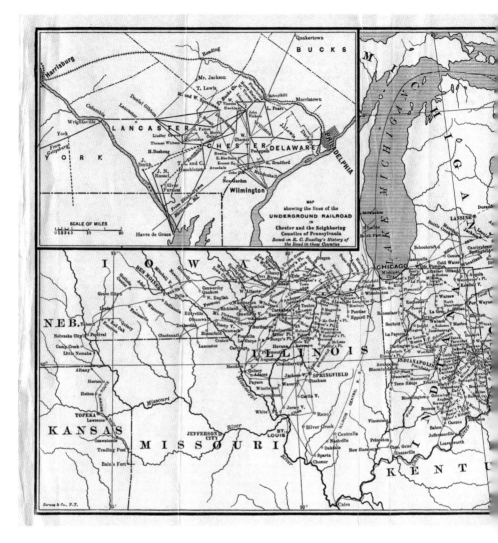

Map of the Underground Railroad system showing routes up the east and west shores of Sebago Lake. *From Wilbur Seibert's book published 1898.*

Portland became the source of several overland routes to Canada. Two of these routes went directly through the Sebago Lakes Region on either side of Sebago Lake, joining at Bridgton. From there, another overland route led into New Hampshire and Vermont, then on to Canada.

Caroline Grimm has written a novel about the Sebago Lakes District Underground Railroad activity, titled *Beneath Freedom's Wing.* Grimm's fascinating account of the abolitionist movement in the South Bridgton

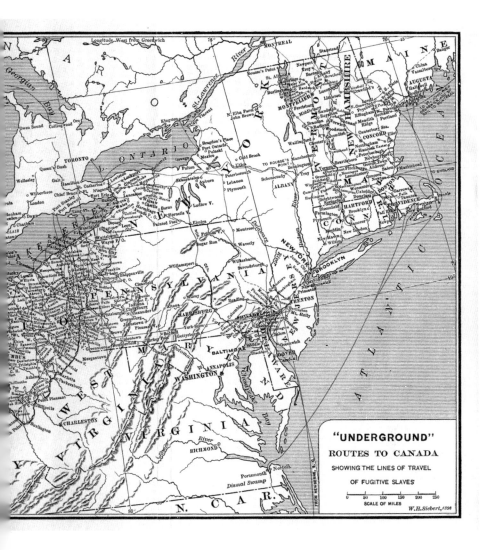

"UNDERGROUND" ROUTES TO CANADA SHOWING THE LINES OF TRAVEL OF FUGITIVE SLAVES

SCALE OF MILES

W. H. Siebert, 1898

area in particular is based on primary research in the form of letters and diary accounts of another branch of the Fessenden family—the brother of Samuel and uncle of William Pitt. The Underground Railroad activity in South Bridgton is a documented fact, and Grimm's story features two houses that are rumored to be stops used during the flight of fugitives escaping to Canada. Both houses have rooms that could have been used as hiding places for escaped slaves, according to Grimm.

There are many buildings in the Sebago Lakes Region that date back to the early nineteenth century, and it is not a stretch of the imagination to believe

that a few of them may have been used as stations on the Underground Railroad. Some of these buildings are on the Underground Railroad route map that is depicted in Seibert's book. One rumored stop was on Route 107 in the town of Sebago on the west side of Sebago Lake. The wooden building constructed in 1848, known as Sebago House, was first used as a tavern and inn with an upstairs dance hall. In the basement is a secret room, accessible from an upstairs taproom, that some believe was used to harbor escaping slaves, though this idea is not officially documented. The house has been most recently used as a private residence.

Nearby, on Fosterville Road in South Bridgton, is another residence that, according to Grimm, may have been used as an Underground Railroad station. This house, now a private residence, is also rumored to have a secret room used to shelter fugitives. Not coincidentally, the house sits next to a Congregational church established in 1829. Congregationalists were known to be sympathetic to the abolitionist movement and supportive of Underground Railroad efforts. Pastor Joseph Fessenden, brother of Portland abolitionist Samuel Fessenden, was this church's first minister, and it is his story and that of his wife, Phebe Beach Fessenden, that are told in Grimm's *Beneath Freedom's Wing*. Grimm suggests that it seems likely that, as an Underground Railroad agent, Samuel routed fugitives from Portland to his brother in South Bridgton. The fugitives then made their passage to freedom in Canada by way of various routes and possibly by way of Canaan, Vermont, where the Beach family lived.

It was not just sympathetic white folks who aided escaping fugitives in their efforts to reach Canada. Free blacks were also very active in this endeavor. According to Price and Talbot, authors of *Maine's Visible Black Presence*, several towns in the Sebago Lakes Region had black citizens listed in census records from 1820 to 1870, including Bridgton, Casco, Gorham, Gray, Harrison, Naples, New Gloucester, Raymond, Sebago, Standish, Westbrook and Windham.

The towns of Windham and Casco had active Quaker settlements, another religious group known to be sympathetic to antislavery efforts and to helping runaways. Additionally, the Sebago Lakes Region had many resident veterans of the Revolutionary War, and according to Price and Talbot, those veterans often believed that what they had fought for was meant for blacks, too. Some of the efforts of these residents have been documented. In 1928, when eighty-four-year-old Windham resident Phebe Pope was interviewed by the *Portland Evening Express*, she related a story about how her Quaker family once helped a young runaway. She said that her grandfather's

Popeville (Windham) house was a station, and she remembered that one day a young teenage boy came to the house from Portland in need of help. His master had followed him, and the boy was frightened nearly to death.

"Plans were made that if his master came and found him, the factory bell would ring. The Windham Hill Church would take up the message and the men for miles around would gather to confront the slave holder," said Pope, who was quoted in the Price and Talbot book. The next night, Pope continued, Dr. Addison Parsons carried the boy in his covered wagon to the next station on the route. Maine History Online has a section dealing with other documented records regarding Underground Railroad efforts in the state outside the Sebago Lakes Region.

Part IV

INDUSTRIAL ENDEAVORS

A Case of Industrial Espionage at America's First Woolen Mill

In the eighteenth century, the Mayall family operated successful woolen mills in old England. Late in that century, Jonnie Mayall thought it would be a good idea to start a woolen mill in America, where there were lots of sheep and little regulation, so he persuaded his nephew Samuel Mayall to start a mill in New England. There was just one problem. The Manufacturer's Guild of England tightly regulated the woolen industry, and the rules forbade anyone from taking equipment or any trade secrets out of that country. Undaunted, Samuel Mayall wrapped his British looms in bolts of cloth meant for trade with the Native Americans and set sail for America.

Mayall eventually set up shop in Gray in the Sebago Lakes Region. In 1791, he began to weave cloth with the smuggled machinery, operated by the power of Collyer Brook. It became the first successful water-powered woolen mill in America (North Carolina also claims to have had the first woolen mill). Back in England, the manufacturing guild was not happy. Samuel Mayall began to receive mysterious gifts. One gift was a wooden chest that contained a loaded pistol rigged to fire when the lid was lifted. This trick failed to do any damage, however. Another gift was a hat with poison-tipped needles concealed in the lining. Again, a suspicious Mayall managed to avoid any harm.

Over the years, Mayall prospered in Gray, making cloth out of wool from the sheep of local farmers. Mayall expanded his operation by building a second woolen mill in 1816. According to Gray Historical Society member Audrey Burns, Samuel Mayall was so enthralled with sheep that he built an underground tomb in the middle of a sheep pasture on his own property near

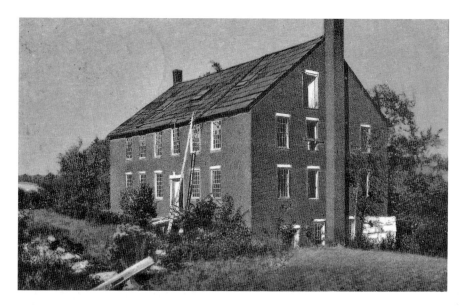

Early postcard view of the Mayall Mills in Gray. *Gray Historical Society.*

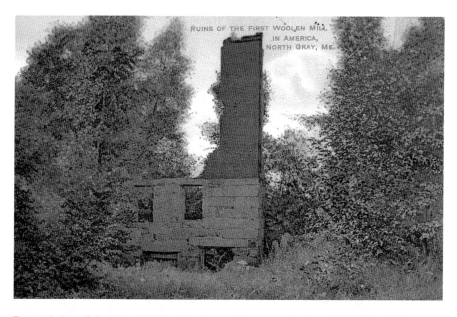

Postcard view of the Mayall Mills ruins that can be seen today from Mayall Road. *Gray Historical Society.*

Ruins of the steps to the underground Samuel Mayall tomb on the mill property. *Gray Historical Society.*

the mill. He wished to be buried there after his death because he believed in reincarnation and hoped to spend his next life as a sheep. After he died in 1831, Mayall was indeed laid to rest in the pasture tomb, but his body was later moved to the Gray Village Cemetery, according to Burns.

After Samuel's death, two of his three daughters, Mary and Phanela, took over the woolen mill operation. They proved to be successful business owners, and the mills prospered under their direction. Mayall also had five sons. One of them, also named Samuel, served as a Democrat in the Maine legislature from 1853 to 1855 but left the party when President Franklin Pierce opened the door to expanded slavery in the Midwest. Samuel Jr. was adamantly opposed to that "peculiar institution." When the Civil War broke out, young Samuel served in the Union Army, likely dressed in a uniform made of the wool processed in his sisters' mill in Gray. During the war, the Mayall Mills did a booming business providing wool for the troops. The Mayall sisters sold the woolen mills in 1879, and the mills ceased operation in 1902 or '03.

Today, you can see the ruins of the Upper and Lower Mayall Mills on Megquire Road, just off Mayall Road in Gray. The site is owned by the Maine Bureau of Parks and Lands and managed with the help of the town of Gray. The area has three informational signs about the history of the mills. There are no groomed trails, but the ruins are visible from the road.

STONES AND BONES

There is a lot of hidden history in old graveyards, but it is not easy to uncover it unless you know what to look for. When the early Sebago Lakes Region settlers buried their dead on their own property, they often marked their graves with a simple fieldstone or wooden cross. Many of these old grave markers have been lost or destroyed, but sometimes descendants who know the whereabouts of these early family plots call Wayne Holmquist, president of the Raymond Casco Historical Society, to ask for help in locating the graves of their ancestors. Other families may be aware that there is a burial ground on their property, but they are unsure of its location. Holmquist is a dowser, someone who can locate lost objects, metal or water by use of a divining tool. Holmquist says that once he has located an unmarked grave, he can determine whether the body is male or female by holding a plumb bob over the site. The pendulum swings back and forth if the body is female and in a circle if it is male.

"Christian burials face their dead to the east so that when they rise up, they will be facing the sun. A wife is usually buried next to her husband with her right hand next to her husband's left hand," he said. Holmquist says he has been able to locate quite a few unmarked gravesites by dowsing.

Headstones reveal much about the persons they memorialize, and they also offer clues to the history of the culture and the artist who created them. In the early 1700s, settlers of the Sebago Lakes Region would have to go to Portland and then by sea to Boston to commission carved gravestones. Such a trip was cost prohibitive for many families. Stones of this period

Portrait gravestone carving by Bartlett Adams. *Author photo.*

were carved with winged skulls or skulls and crossbones, the typical motif for death of that period, according to Ron Romano, a board member of Spirits Alive, an organization that supports, preserves and studies the graves at Eastern Cemetery, Portland's oldest city burial ground.

By the mid-1700s, gravestone carvings sometimes depicted winged cherubs or angels, symbolizing the soul separating from the body. Also, portrait stones trended, showing carvings of the deceased's bust and face. It wasn't until the 1800s that urns and willows were used as symbols, and by then,

marble, sandstone and limestone were being used for gravestones in addition to slate. Those materials were easier to carve, though they deteriorated more quickly over time, according to Romano. In the Sebago Lakes Region, gravestones of this period were mostly made of slate and marble.

One of the foremost carvers of gravestones of the early nineteenth century was Bartlett Adams (1776–1828), who came to Portland and opened for business in 1800. At that time, the population of Portland was 3,700. Adams immediately took out an ad promoting himself as a "sculptor" and stonecutter of doorjambs, mantle pieces and gravestones. At first, he did a lot of business filling back orders for carved gravestones, as evidenced by the many backdated stones in southern Maine cemeteries. From 1800 to 1828, Adams had a corner on the carved gravestone market in southern Maine. Mortality rates were high, and Adams was the only stonecutter in the area.

Adams's stones can also be found in the many village cemeteries in the Sebago Lakes Region. Romano, who gives slide show presentations about Adams and his work to local and national organizations, has identified at least eighteen stones in Gray Village Cemetery as products of the Adams shop, for example. In the New Gloucester Lower Corner Cemetery, sixty-five stones have been attributed to Adams's shop. In a twenty-five-mile radius of Portland, about 1,500 stones are believed to have been carved in his shop by either Adams himself or his apprentices, according to Romano, who is researching a book about the sculptor.

Adams's style was, for the most part, simple. Many of his stones are carved with willows, which show a broken branch, symbolizing a life cut short. Others are carved with classic urns, bellflowers, chain swags and semicircles. Adams's work also has some unique twists, including elegant scripting and intricate rosettes.

Bartlett Adams's most acclaimed carving was the capstone for the table tomb memorial of the American naval commander William Burrows, who was killed at age twenty-seven or twenty-eight off the coast of Pemaquid Point. On September 5, 1813, during the War of 1812, the USS *Enterprise* sighted the HMS *Boxer*, commanded by twenty-nine-year-old Samuel Blyth. It was a fight to the finish for both commanders. Blyth was killed outright by a cannonball that almost cut him in half during the opening fusillade, and Burrows was mortally wounded by musket fire almost at the same time. In the end, the *Enterprise* defeated the *Boxer*. A few days later, both officers' elaborate funerals were conducted in Portland, and the men were laid to rest side by side in the city's Eastern Cemetery. Visitors today will see three similar table memorials, the third

Table memorials of Waters, Burrows and Blyth in Portland's Eastern Cemetery. *Author photo.*

belonging to Lieutenant Kerwin Waters, who was also wounded in the battle but lived two more years.

Adams was commissioned to carve the capstone for the Burrows memorial, and Romano suspects that since Adams was the only carver in Portland, he may have carved all three capstones of the table monuments. No one is sure what they looked like. Newspaper accounts of the day described the Burrows capstone carving as a fine piece of art, according to Romano. However, time and the salty sea air took their toll on the stone, and it has since been replaced two or three times. The current stone, installed in 1959, is simply inscribed with text that reads in part: "Beneath this stone moulders the body of Captain William Burrowes [*sic*] Late Commander of the United States Brig Enterprise who was mortally wounded in the 5th day of Sept. 1813 in an action which contributed to increase the fame of American valor by capturing His Britannic Majesty's Brig Boxer after a severe contest of forty-five minutes."

Bartlett Adams married Charlotte Neal in 1803, and they lived in Portland. They also had a farm in the Sebago Lakes Region in New Gloucester, where they lived during Adams's brief hiatus from stonecutting. The couple had

Gravestones carved by Bartlett Adams for his children. *Author photo.*

seven children; sadly, only two survived to adulthood. Three of the Adams offspring died within six years of each other, and they are buried side by side in Portland's Eastern Cemetery, their graves marked by stones carved by their father. As each died—Bartlett Jr. in 1806, George in 1809 and Eliza in 1812—the stones got a little smaller. Each stone is inscribed with the words *Si Memoria Sacrum*, in sacred memory. The ornate stone for Adams's son Bartlett Jr., who died at age six months, is perhaps his most complex carving. The only other son, George, lived only six hours. Adams carved this curious epitaph on George's grave: "Thrice happy babe, thy voyage was quickly o'er. Millions may wish their lives had been as short." The curious and melancholy words reflect the misery and suffering of the grieving parents.

Three other Adams children are buried in a family tomb in Eastern Cemetery, and when Bartlett Adams died at age fifty-one, his body was laid to rest there as well. Bartlett Adams's marker probably came from his own shop, but today the ledger stone over the tomb is missing. Ironically, the only marker that exists there today is a small stone marking the entrance to the family tomb where the body of one of early America's finest gravestone carvers was laid to rest.

MASTS, TAR AND CHEWING GUM

In the seventeenth century, Great Britain looked to colonial New England with its vast forests of old growth white pines for its supply of Royal Navy ships' masts. Some of these magnificent trees were harvested from the Sebago Lakes District of Maine.

According to David Tanguay, vice-president of the Windham Historical Society, for every inch in diameter, the mast had to be a yard in length when finished. For example, a thirty-six inch mast at the butt end would be thirty-six yards long. Some masts exceeded forty-two inches in diameter. The trees selected for mast making had to be massive. An agent of the British Royal Navy would go into the woods and select a tall straight pine free of blemishes. The tree would then be marked with a symbol of the king's broad arrow, or "kingsmark," carved into the bark indicating it was the property of the king. Anyone who violated the king's mark and cut down the tree was considered a criminal, and sometimes agents went into the settlers' homes to measure the width of the floorboards to ascertain that the builder had not used a tree belonging to the king. The marked tree was later chopped down onto a thick bed of boughs to cushion its fall. For every five hundred king's pine trees marked, fewer than one became a mast for a number of reasons, said Tanguay, including rotten cores and breakage upon impact with the ground when they fell.

The Sebago Lakes Region's many lakes and rivers were used when possible to float the timber in the direction of the sea. More often, the timber was hauled across the frozen ground in winter with great difficulty

The king's broad arrow carved into a tree trunk. *Windham Historical Society.*

to Stroudwater (now Portland) and loaded aboard the mast fleet and sailed to Great Britain. These vessels had openings in the stern through which the masts were pushed. The largest of the stern ships, according to Tanguay, could carry forty-five to fifty masts below deck, with smaller masts and spars above deck.

Keep in mind that some of these masts contained seven to eight thousand board feet of lumber, enough to build a house. Mast timbers harvested from the Raymond/Casco/Windham area were hauled by oxen, six span on each side and six behind to act as brake, and hauled overland roughly following what is now busy Route 302. Manipulating a mast around a curve in the road was difficult, as Casco resident Lewis Gay discovered. Farmer Gay lived on Quaker Ridge Road from 1786 to 1823. According to historian Ernest H. Knight, Gay supplied masts for trade in the winter. One day, as he was hauling a long mast timber around a curve in the road, it became stuck or "pinched," and that particularly bad curve is still known today as "Gay's Pinch."

Alvin Morrison pinpoints the exact location of Gay's Pinch, on his Sebago-Presumpscot Anthropology website: "Head north on Rt. 302 beyond North Windham's business district, past the White Bridge Road intersection. Look on the left for signs saying 'Forest Pump & Filter Inc.' and 'Faith Lutheran Church.' Not far beyond Forest Pump, but just before the church's driveway,

and roughly parallel to it, are two paths leading roughly to the west of 302. Ignore the highland path (it is an ATV trail atop the crude-oil pipeline to Montreal). The lowland path (just under the churchyard banking) curves southwesterly out of sight. This was once the old road to Portland, and this spot was the location of Gay's Pinch."

Portland-native poet Henry Wadsworth Longfellow celebrated the Maine mast connection with these verses in his poem "The Building of the Ship":

Behold, at last,
Each tall and tapering mast
Is swung into its place;
Shrouds and stays
Holding it firm and fast!
Long ago,
In the deer-haunted forests of Maine,
When upon mountain and plain
Lay the snow,
They fell,—those lordly pines!
Those grand, majestic pines!
'Mid shouts and cheers
The jaded steers,
Panting beneath the goad,
Dragged down the weary, winding road
Those captive kings so straight and tall,
To be shorn of their streaming hair,
And, naked and bare,
To feel the stress and the strain
Of the wind and the reeling main,
Whose roar
Would remind them forevermore
Of their native forests they should not see again.

The mast trade eventually ended, but the trees of the Sebago Lakes Region continued to support the woodsmen in other ways. Historian Ernest H. Knight reported that the extraction of tar from resinous coniferous trees in the area gave names to such places as Tarkiln Hill and Tarkiln Road in Raymond. Pine tar is a black, sticky material extracted from wood in an oven known as a tarkiln. In colonial America, pine tar was used as a waterproofing and preservative substance for roofs and boats.

Tall masted ship, painted by Henry Scott Tuke. *Wikimedia Commons public domain image.*

A closely related foresting industry in the Sebago Lakes Region was the gathering of spruce gum. That's right, chewing gum from a tree, and there was a time when you could buy it in many stores. In its pure form, spruce gum is the hardened resin of the spruce tree. It is tough and crumbly at first, but once in the mouth for a bit, it eventually becomes chewable, though it is not at all sweet and soft as are today's commercial chewing gums.

From the mid-1800s to the early 1900s, there were eighteen companies in the United States producing spruce gum. The Curtis & Son gum company in Portland, established in 1850, was the first gum factory built in the United States. By 1898, the company employed approximately 120 workers producing five thousand pounds of product daily, representing a retail value of $2,500. Much of the raw material for the gum came from the nearby Maine woods, including the Sebago Lakes Region forests.

Gatherers of the spruce resin, called "pickers," were paid to collect the amber colored substance that was a main ingredient in the commercially produced chewing gum. According to a May 1913 *New York Times* article: "Anyone who can climb a tree and is willing to dig hard into the spruce limbs can make $1 to $6 a day in the gum business, for the crop never fails, and Maine produces more spruce gum than all the other states combined." At the turn of the century, the Maine woods yielded a 150-ton harvest of raw spruce gum and a $300,000 business for the pickers.

Today, it is difficult to find real spruce gum, although an online search yielded a few merchants offering spruce gum for sale, and YouTube offers a tutorial for the hobbyist on how to cook up a batch on the kitchen stove. Purists, of course, can simply go into the woods and scrape a chaw straight off a tree. It is fragrant and, well, pungent enough to clear the sinuses. Let's say it is an acquired taste. Just remember that the same substance was also used to waterproof boats.

GUNPOWDER FOR THE CIVIL WAR, AN EXPLOSIVE BUSINESS

Visitors to the Gambo Falls area of the Presumpscot River can view the ruins of the Oriental Powder Mills Company that produced more than one-fourth of the military-grade gunpowder used by the Union forces during the American Civil War. Gunpowder production at the site dates back to 1824, when Lester Laflin and Edmund Fowler of Massachusetts built the first mill on the Gorham side of the Presumpscot. Operations later expanded to include structures on both the Windham and Gorham sides of the river. Laflin and Fowler died in a tragic boating accident on Sebago Lake in 1827. The accident was the first of many tragedies to be associated with the mills.

A walking trail now leads past some of the old foundations of the buildings that once stood there—at one time, there were more than fifty structures on both sides of the Presumpscot. The buildings were erected far apart in order to lessen the chances of a fire spreading from one building to the next in the event of an explosion. These disasters occurred almost yearly at the Oriental Powder Mills (locally known as the Gambo Powder Mills) during the late nineteenth century. It was the scene of many deaths and dismemberments. In fact, between July 19, 1829, and February 7, 1901, there were twenty-five explosions at the mill, killing forty-five men and severely burning and injuring many others. A major explosion on October 12, 1855, killed seven workers, including owner Oliver Whipple's brother and son.

The newspaper accounts of the explosions were grisly. After the October 12, 1855 explosion, the *Eastern Argus* reported:

Glaze mill building of Oriental Powder Mills. *Windham Historical Society.*

All that remains today of the foundation of the round mill. *Author photo.*

The press mill had 300 kegs of powder, and a quantity loose…Phinney, after the explosion walked several rods until he met a man who spoke to him, and he instantly fell dead. Swett was thrown nearly a quarter of a mile. Hawkes had his bowels blown out, and one side of his head blown off. A cart to which a yoke of oxen were attached, was shattered to fragments, and the hair was burned off the oxen almost entirely. A buggy wagon was also blown to pieces, and the horse driven, like a wedge, into a pile of lumber. The fragments of the buildings were thrown by the violence of the explosion, up a hill a quarter of a mile distant, lining its sides with the timbers, which seemed to have plowed their way up through the soil where they first struck. A large portion of the wharf was demolished, and a large stick of timber, some two feet in thickness, lying upon it, was broken in pieces like a pipe stem.

At least one of the victims of the many explosions is buried in nearby Loveitt Cemetery. Thomas Bickford's tombstone inscription reads: "Killed by the explosion of powder mill Sept. 24, 1851, Aet. 47 Yrs."

In his book, *Windham, Maine: 1734–1935, The Story of a Typical New England Town*, Frederick H. Dole reminisces about hearing the explosions from his nearby childhood home: "All eyes would be turned at once towards the river, where a great cloud of smoke could be seen rising toward heaven. Just think of the emotions of the families and friends of the men who worked there! It is true that a mill [building] would be occupied by only two or three men at a time, so the disaster would be no greater. And yet at almost every "blow-up" two or more men whom we had known from childhood had been blown to fragments."

But the pay was good and the work was light, so the mill was never in short supply of workers. During the Civil War, when owners feared that the draft would reduce the supply of mill

Gravestone of Thomas Bickford, killed in a mill explosion. *Author photo.*

workers, one of the company's officers asked the governor to exempt the Oriental Powder Company workers from the draft. The mill attorney argued that a worker engaged in the production of gunpowder during a war was of more service than he would be as a soldier, and he faced more risks working at the mill than he would in battle. Governor Washburn agreed, and the Oriental Powder Company workers were exempted from the draft. Peak annual production during the Civil War years exceeded 2,500,000 pounds. Production of gunpowder ceased in 1904.

In his book, Dole remembers that there was a spirit of fatalism among the workers: "They believed that if their time had come it made no difference where they were, and that their chances were more than even that it would not come to them there." But for Dole, the site of the mill and the memory of its operation was melancholy: "That large forest which was closed to all but workmen when the author was a boy, looks as gloomy and forbidding as ever. It was the scene of many a terrible tragedy, mercifully concealed from the common gaze by those thick pines, and the dark forbidding stream of the Presumpscot, which proved the Styx to forty-five men in the glow and hope of sturdy manhood. Never can it be otherwise than gloomy and tragic to those of us who lost friend after friend in its forbidding shades."

Today, no one is alive who can remember the explosions, and it is easy to forget that the site was once the scene of so much tragedy. In fact, a hike through the area on a summer afternoon can be quite pleasant. Starting near the dam on old Gambo Road, the Gunpowder Mill Trail tours the entire grounds of the former mill. Wayside markers beside the trail describe the significance of each ruin. The Maine Historical Society has an impressive online display commemorating the mill.

THE GULICK CAMPS

Each year, more than twenty thousand boys and girls experience Maine summer camps. The shores of the lakes and ponds in the Sebago Lakes Region are dotted with these camps. There are camps just for boys and some just for girls. Others are co-ed, and at least one is for brother-and-sister combinations. Some identify with specific religious affiliations, and one is for children coping with life-threatening illnesses.

Two of the oldest summer camps in Maine are Camp Wohelo for girls in Raymond on the shores of Sebago Lake and Camp Timanous for boys on nearby Panther Pond. These camps, both more than a century old, were the progenitors of the overnight summer camping industry that is so firmly rooted in the Sebago Lakes Region today. Camp Timanous was founded in Connecticut in 1887 by Dr. Luther Halsey Gulick (1865–1918), a physician and physical fitness pioneer. Dr. Gulick is still honored today for his work with the YMCA and the design of its triangular logo. Dr. Gulick moved Timanous to Maine in 1920. By then, Dr. Gulick and his wife, Charlotte Vedder Gulick (1865–1938), had founded the Camp Fire Girls, the first nonsectarian, multicultural organization for girls in America. That organization was renamed Camp Fire and, in 1975, opened its membership to boys.

Wohelo Camps were founded in 1907 by the Gulicks. According to the Wohelo website, there are two camps separated by a half mile, one for girls ages six to twelve, called Little Wohelo, and the other for girls ages twelve to sixteen, called Sebago Wohelo. The name "Wohelo" was extracted from

Camp Fire Girls photo taken at Sebago Lake. *Library of Congress.*

the first two letters of the words "work," "health" and "love," the three principles that were the foundation of the Gulicks' lifelong dedication to helping children have a well-rounded life.

Camp Fire Girls with their leader, Charlotte Gulick, making fire. *Library of Congress.*

Although we may take efforts in behalf of gender equality for granted today, in the early 1900s when Camp Fire Girls and Wohelo were founded, the creation of an all-girls club and camp was groundbreaking business. In her history of Camp Fire, Alice Marie Beard writes that on April 10, 1911, the Boy Scouts of America issued a press release announcing the formation of a similar organization for girls to be known as Camp Fire Girls of America. The announcement read in part: "The aim of the organization is to provide for girls outdoor activities corresponding to those furnished boys by the Boy Scout movement. It seeks to encourage a greater interest among girls in exercises in the open with the threefold aim of developing their bodies, mind and characters." The press release goes on to note, however, that activities provided for girls "must be fundamentally different from those of boys and that special attention must be paid to the home."

The children who attend summer camps in the Sebago Lakes Region today and their counselors enjoy many of the same activities that they did one hundred years ago—swimming, canoeing, sailing, crafts, campfires and singing. Some of the owners of the camps have carried on the business for two or three generations in the same family. Dr. Luther Halsey Gulick and Charlotte Vedder Gulick set the bar high for the summer camp industry in the Sebago Lakes District and the entire state of Maine.

Part V

TRAGEDY AND TRAVESTY

FROZEN TO DEATH ON THE CAPE

Maine is known for its harsh winters, but none was as harsh as the winter of 1816. It may have been part of a cycle of winters including the year 1816, which was known as the "year without summer" because there were frost and snow in every month. It was also known as "the poverty year." The persistent frosts in Maine and other parts of the northern hemisphere created widespread food shortages. That year was also called "eighteen hundred and froze to death," which became the literal truth for one Raymond Cape couple a few years later in March 1819.

Samuel (one source names him Jeremiah) Tarbox, his wife and their four (another source says five) children lived on the extreme end point of Raymond Cape within the line of Standish. Mrs. Tarbox's first name has disappeared from the historical record. On the afternoon of March 12, 1819, it began to snow and continued unabated for three days, with the wind whipping the snow into great drifts. On the third day of the storm, the Tarbox family was running low on food, so Samuel set off on foot with a bag of corn on his back to have it ground into meal at the nearby Dingley gristmill. This mill was built in 1772 by Joseph Dingley and was later operated by Dingley's son Samuel. The mill was very near the childhood home of Nathaniel Hathorne (later changed to Hawthorne), whose aunt Susan and uncle Richard Manning lived across the road, also in view of the gristmill.

Apparently, Samuel accomplished the five-mile walk and finally reached the mill, though the storm was fierce. The corn was ground, and Samuel set out on the return trip. Suddenly, the storm increased in fury, and Samuel

could scarcely negotiate the path, especially with the heavy load of cornmeal tied to his back. He fastened the bag of meal to a low tree limb and struggled on toward his home through the cold and blinding snow. Just as he reached his yard, he collapsed in the snow and could go no farther.

Samuel cried out to his wife for help. Inside their small house, Mrs. Tarbox waited anxiously for her husband's return. As darkness began to fall, she thought she heard her husband call out to her, but she could not be sure as the wind was howling and the snow beat upon the windows. Worried, she told the children to stay inside while she put on her woolen cloak and hood. Mrs. Tarbox instructed the children to sound a horn at intervals so that she or other rescuers would have some reference of location in the blinding snow. Then she set off to find her husband.

Mrs. Tarbox was probably surprised to find him just a few feet from the door, but she was unable to move him so she covered his freezing body with her cloak and hood and struck off to a neighbor's for help. She had not gone far when she, too, collapsed. It would be two days before the stiff, frozen bodies of Mr. and Mrs. Tarbox would be found by a woodsman who was alerted to the situation by the intermittent sounds of the children's horn.

A horrified Nathaniel Hathorne reportedly watched the burial of Mr. and Mrs. Tarbox from an upstairs window of the Manning house. Although there are two cemeteries in the vicinity (one is on private property), this writer has not been able to locate any Tarbox grave markers, but as the family was poor, they may not have had typical gravestones as we know them today. It also seems unlikely that the Tarboxes would have been buried near the Mannings, five miles from their own home, since the pioneers then were usually buried on their own property with a fieldstone or wood cross to mark the grave. Historian Ernest H. Knight reported that as late as 1996, at the far end of Raymond Cape, near Frye's Leap, there was an outline of stones that could be the site of the Tarbox house. Mr. and Mrs. Tarbox may be buried nearby. In some of the old families of Raymond, there are still those who refer to a fierce winter storm as a "real Tarboxer."

The youngest of the Tarbox children, little three-year-old Betsy, was adopted by Nathaniel Hathorne's aunt and uncle Manning, who had no children of their own. One Nathaniel Hawthorne scholar has speculated that the Tarbox tragedy and adoption of Betsy may have inspired such stories as "The Gentle Boy" and "My Kinsman, Major Molineux" about boys who are cut off from their families and go in search of their true heritage. Young Nat apparently became very fond of his little "cousin." In a diary entry reported to be that of young Nat Hathorne, he wrote: "I can

from my chamber window look across into Aunt Manning's garden, this morning, and see little Betty Tarbox, flitting among the rosebushes, and in and out of the arbor, like a tiny witch. She will never realize the calamity that came upon her brothers and sisters, that terrible night when her father and mother lay within a few rods of each other, in the snow, freezing to death. I love the elf, because of her loss; and still my aunt is much more to her than her own mother, in her poverty, could have been."

Balladeer Thomas Shaw (1753–1838) eulogized the Tarbox couple in verse published in 1819. Shaw lived in Standish and self-published and sold his ballads. Most of his ballads were based on doleful stories and printed on sheets trimmed with drawings of coffins. They were carried to distant lands by sailors of Portland Harbor. Shaw's "Mournful Song" ballad makes Mrs. Tarbox the tragic hero. Shaw has immortalized her in poetry, though her full name may be forever lost to the historical record.

MOURNFUL SONG (excerpt)
On a man and wife, who both froze to death in one night, on Standish Cape, so called

Attend my soul and hear the sound,
That's solemnly a passing round,
That strikes each heart and listening ear
To hear the solemn sound draw near.
Husbands and wives may now attend,
And let your hearts to heaven ascend,
While I unto you make known,
A solemn stroke as e'er was born.
Let children too draw round and hear
With trembling hearts and holy fear,
With all our neighbours all as one
And listen till my story's done.
And thou great God pray lead my heart
And mind to act my solemn part,
In this affair before our eyes,
Which stricketh all hearts with surprise.
Good Lord confound every one
Who ever to these lines makes fun,
That they may hide their heads with shame,
Or brought to praise thy holy name.

And now the story I shall tell,
Who am informed of it full well,
And O my soul what can this mean
A real or a fancied dream.
O yes it is the truth I tell,
On Standish Cape these two did dwell,
Together liv'd as man and wife,
Until ended their day of life.
This man for food abroad did go
In a snow storm in a deep snow,
At his return his strength gave way,
Which brought him to his dying day.
Under his load he seemed to fall,
And then aloud for help did call,
His wife his dying sound did hear
Then for his help did soon repair.
She left her children then with speed
To help her husband then in need,
Through cold and wind in a deep snow,
God knows what she did undergo.
She met her husband in a fright
Through winds and snow on a cold night,
Whom she most lovingly did own
To save his life she lost her own.
She took her clothes from off her frame
And on her husband plac'd the same,
For help she cried aloud and strong
Was her last fierce and mournful song.
O there she tended on her man
When he could neither go nor stand,
And when lain out upon the snow,
God knows what she did undergo.
Dead or alive we cannot tell,
God only knows the scene full well,
And her great cries that God would Save
Her husband from the gapeing grave.
Trouble and grief, sorrow and woe,
This good woman did undergo,
There nursed her husband in the cold,

Which makes our chill'd blood run cold.
We cannot tell, nor can we show,
To others what we do not know,
But this we say a doleful night,
Upon this man and wife did light.
Without a covering or a hed
That woman then in doleful dread,
Tended her man in cold and snow,
God knows what they did undergo.
Tempestuous winds and storm of snow
About this man and wife did blow,
Distress'd in body and in mind
This woman thought some help to find.
Her husband to God did convey,
So then for help she steer'd her way,
With solemn groans ascending high
While her poor children heard her cry.
Soon feeble woman took her flight
For help upon this doleful night,
For help she sought, for help she cried.
Where human help was then denied.
Towards her neighbors she did steer
Through snow and wind and doleful fear,
With solemn cries that God would save
Her, and mercy upon her have.
She went as long as she could stand,
Aiming for human help at hand,
With bitter groans and solemn cries
That did before the Lord arise.
And then she crept upon all four,
Until her clothes from her were tore,
The snow flying—sorrow and woe,
God only knew her trouble too.
Her solemn cries arose on high
Her children hearing of her cry,
Which did distress each thoughtful mind,
While they could not their parent find.
Their Father lying in the snow,
Their Mother for help tried to go,

Creeping and crying as she went
Until her life was almost spent.
She crept till to a bloody gore,
Her flesh was into pieces tore,
God only knew her heart-felt cries,
Which did unto the heavens arise.
Until at last gave up her race,
And her self too, to sovereign grace,
And with her doleful cries severe,
Which reached to her Saviours ear.
Her cries we say to heaven arose,
Then did her troubled heart compose,
What time it was we cannot tell,
She bid her troubles all farewell.
And these she died, her husband too,
Both of them perish'd in the snow,
And gone to rest we humble trust,
As all good people surely must.

THE BRUTAL MURDER OF MARY KNIGHT

S ome folks believe that the spirit of Mary Knight wanders Route 26 and the back roads in Poland, Maine, where she was brutally murdered by her husband on October 6, 1856. The story is gruesome, even by today's standards, and at the time was so shocking that the *New York Times* ran an account of the crime.

When Mary Polly Pratt Knight's first husband, Solomon, died in 1840, Mary married her late husband's brother, twenty-three-year-old George. Mary, who had six or seven children with Solomon, was twenty years older than her new husband. At the time of the murder, the Knight household included Mary and George, George's elderly mother, Lydia Knight, as well as Hannah Partridge, a thirteen-year-old relative, and Sidney Verrill, a ten-year-old boy apprenticing with George.

Apparently, Mary had been feeling under the weather for several weeks before her death. She complained of vomiting, weakness, headaches and stomach pains. She told her daughter that she suspected she was being poisoned. On the morning before her murder, Mary's physician, Dr. Carr, reported to George that Mary seemed to be showing some improvement in her condition. Later that same evening, George loaded his wagon with shingles that he planned to take to a buyer in nearby Dry Mills that night.

Mary retired early that evening, soon after George's departure. For some reason, instead of sleeping in her own bed, she crawled into bed with her mother-in-law, eighty-three-year-old Lydia. At about midnight, Lydia, who was very hard of hearing, claimed that she heard a cry from Mary and

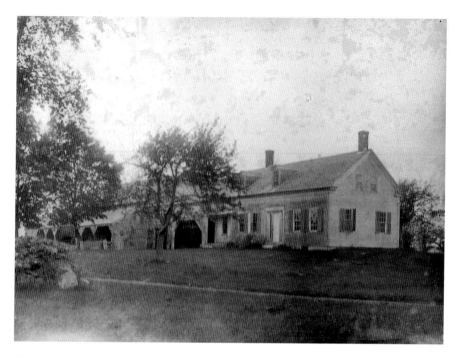

The scene of the crime, the Knight farmhouse in Poland. *Poland Historical Society.*

immediately felt Mary's arms fall upon her, which frightened her enough so that she arose in the darkness and ran out of the room. Lydia testified that she did not see a third person in the room with her and Mary. The children in the house were apparently awakened by the outcry, and they, too, arose and went to join Lydia. Together, they decided to return to the bedroom to see what was wrong with Mary. According to the case report, Lydia "with the two little children, with a light, approached the bed-room, the little boy being in advance. As they approached the door, he observed the deceased upon the bed, and perceiving blood, exclaimed, 'Aunt Mary has cut her throat.'"

Sidney ran to the neighbors, who followed him back to the house, all the while thinking that Mary Knight had committed suicide. However, when Dr. Carr later examined the corpse, he found that Mary's nightcap and George's handkerchief had been inserted into the deep cut in her throat, something Mary could not have done herself, as the severity of her wound would not have allowed it. So if Mary had not committed suicide, who killed her? The state charged George Knight with the murder of his wife.

At the trial, George claimed that he had transacted his business in Dry Mills and Gray on the night of the murder and then made his way to Brown's

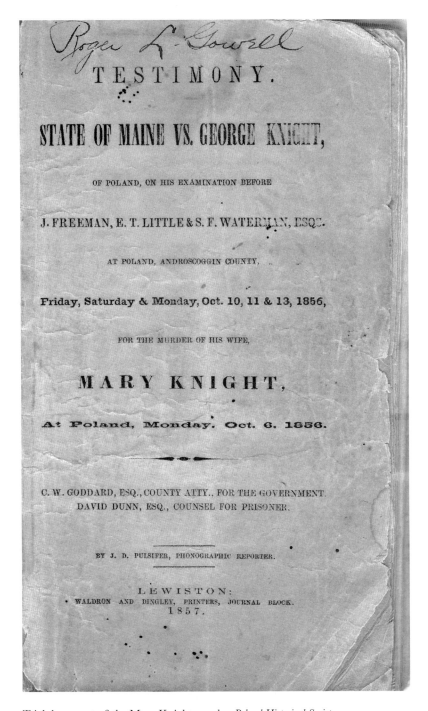

Roger L. Gowell

TESTIMONY.

STATE OF MAINE VS. GEORGE KNIGHT,

OF POLAND, ON HIS EXAMINATION BEFORE

J. FREEMAN, E. T. LITTLE & S. F. WATERMAN, ESQ.

AT POLAND, ANDROSCOGGIN COUNTY,

Friday, Saturday & Monday, Oct. 10, 11 & 13, 1856,

FOR THE MURDER OF HIS WIFE,

MARY KNIGHT,

At Poland, Monday. Oct. 6. 1856.

C. W. GODDARD, ESQ., COUNTY ATTY., FOR THE GOVERNMENT.
DAVID DUNN, ESQ., COUNSEL FOR PRISONER.

BY J. D. PULSIFER, PHONOGRAPHIC REPORTER.

LEWISTON:
WALDRON AND DINGLEY, PRINTERS, JOURNAL BLOCK.
1857.

Trial document of the Mary Knight murder. *Poland Historical Society.*

Tavern, where he had fallen asleep. The prosecutor claimed that this was a lie and that George had actually driven back down the road to his home, left his ox cart by the side of the road, and made his way to the farmhouse where he climbed in the window and cut his wife's throat as she slept by the side of George's mother. Then, according to the prosecution, George went back to his team and proceeded on to the tavern.

One of the pieces of evidence at the trial was a bloody fingerprint left behind by the murderer at the crime scene. The prosecution claimed it was George's. This may well be one of the first instances in which a fingerprint was used as trial evidence.

If George had the opportunity to commit the crime, what was his motive? According to the case report, George may have resented his marriage to a much older woman: "he had allied himself to a woman very much his senior in years (Mary), some years ago, when their disparity of age was not as great as now; that he had conceived the idea of marrying a younger woman; and that on one occasion he had indicated this to one of his neighbors; and that the sickness of his wife was of such a character as to raise suspicions that he had resorted to unjustifiable means to procure her early decease."

George's behavior at Mary's funeral seemed to underscore this point. According to the case report, during the funeral, George was observed "indulging in obscene jests, in frivolity and laughter." The jurors found George Knight guilty of murder. The case report stated: "George Knight…on the sixth day of October last past…feloniously, willfully, and of his express malice aforethought, did make an assult [sic]…in and upon the throat of her…with some cutting instrument and weapon…did cut, stab and thrust and deprive of life…one mortal wound, of the length of five inches, and of the depth of three inches of which said mortal wound, said Mary Knight, then and there, instantly died."

George was convicted of first-degree murder, sentenced to death and sent to the Maine State Prison at Thomaston to await his execution. Then Governor Joshua Chamberlain changed the sentence to life in prison, and George died there and was buried in Poland. Mary Polly Pratt Knight is buried next to her first husband at White Oak Hill Cemetery, which is located in the middle of a private golf course in West Poland. The grave is in a quiet spot next to a picket fence once painted white but now grayed and in disrepair. The inscription on the stone does not give a clue about the tragedy of Mary Polly Pratt Knight's brutal end:

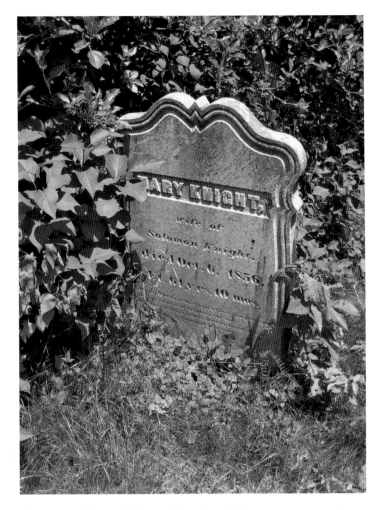

Gravestone of Mary Knight at White Oak Hill Cemetery. *Author photo.*

Mary Knight
Wife of Solomon Knight
Died Oct 6, 1856
AEt. 61 yrs. 10 mos.
Mother, we have laid you to rest in a quiet spot
Where roses will brighten the sod,
But the precious mother, that we loved so well
Now reigns in the kingdom of God.

MALAGA ISLAND, A COMMUNITY ERASED

The Malaga story is one of Maine's most significant chapters of its black history. The Malaga story is also one of Maine's most shameful acts of social misunderstanding and racism. Malaga Island is not located in the Sebago Lakes Region at all, but many of its former residents are buried there, in New Gloucester. How they ended up in the Pineland Cemetery is a strange tale.

Malaga Island, at the mouth of the New Meadows River just south of Bath, was once inhabited by a community of "mixed race" squatters who lived off the land and sea and sometimes worked seasonal jobs on the mainland. Its residents populated the forty-two-acre island from the 1860s to 1912. Most of the island residents descended from Benjamin Darling, believed to be a former slave freed by his master as a reward for saving his master's life during a shipwreck. Darling was black, and his wife, Sarah Proverbs, was white. According to writer Allen Breed, later Malaga residents included Maine-born black man Henry Griffin; fisherman James McKenney, called "King of Malaga"; mason John Eason; Eliza Griffith, who lived in a salvaged schooner cabin and made her living as a fisherwoman; and William Johnson, veteran of the famed Fifty-fourth Massachusetts Colored Regiment.

During the 1890s, some Malaga residents became so poor that they asked the nearby town of Phippsburg for help. Phippsburg claimed that Malaga actually belonged to Harpswell, but that town fought back. The situation worsened when, in 1901, a law was passed stopping the Malagaites from digging clams on the flats around West Bath. Clam

digging was one of the islanders' chief sources of income. In 1905, the impoverished Malaga residents appealed to the state government for help, and Malaga became a ward of the state of Maine, attracting a lot of negative attention from the press.

By 1911, the state decided that the situation on Malaga was hurting Maine's attempts to improve the state's economy through developing tourism. After all, Malaga was just a few yards away from Maine's beautiful coastline. Then, too, Malaga itself, with its coves and island forest, could be considered a pretty spot if it was purged from its deplorable impoverished condition. Malaga was both an eyesore and a tax burden.

In 1912, then governor Frederick Plaisted made an unusually cruel move. He demanded that by July 1: 1. all Malaga residents be evicted; 2. any houses that could not be floated off the island be destroyed; and 3. all of the bodies in the Malaga cemetery be exhumed and reburied in the cemetery at the Maine School for the Feeble-Minded, forty miles away in the Sebago Lakes Region. The state had just recently built the Maine School for the Feeble-Minded in the then popular philosophy of eugenics, which held that institutionalization was the solution for removing mentally ill and developmentally disabled persons from the gene pool. The travesty multiplied.

Workers dug up the remains of the Malagaites' ancestors and placed them in five large caskets. Officials then shipped them by train, and the remains were reburied in the cemetery at the School for the Feeble-Minded. They were buried in three mass graves, marked by a row of nine headstones, engraved with names and the date of November 1912, the date they were reburied. Other stones nearby mark the graves of the deceased from the School for the Feeble-Minded. Their stones contain very little information beyond the name and date of death.

The cemetery, now known as Pineland Cemetery, is located off Route 231 behind Webber Cemetery, at the edge of the Pineland Center grounds. It is not visible from the road, although there is a sign. A granite memorial stone was recently added in 1998, thanks to efforts spearheaded by Elaine Gallant, a concerned individual who was touched by the tragedy of the eviction. Nearby the graves, another plaque educates any visitors to the history of Malaga.

What became of the living Malagaites who were evicted? Some found new homes on the mainland or went to live with relatives. According to author Richard Kimball, one whole family was sent to live at the School for the Feeble-Minded, even though one of the kitchen workers there was distressed about the presence of a mother and daughter she believed were competent

to live on their own. A newspaper reported that the superintendent of the school felt that it "would be altogether unsafe to allow them to leave."

The subsequent name changes for the School for the Feeble-Minded reflect the change in social acceptance and treatment for the mentally ill and developmentally disadvantaged. The School for the Feeble-Minded was renamed the Pownal State School, then Pineland Hospital and Training Ground and then Pineland: A Comprehensive Center for the Developmentally Disabled. Today, it is known as Pineland Center, owned by the Libra Foundation of Portland, and the campus includes a five-thousand-acre working farm located in the rolling hills of New Gloucester. Many of the original buildings have been restored, and the beautifully landscaped grounds now encompass nineteen buildings, including a conference center, a cafeteria, a welcome center and a YMCA. According to Pineland Center's website, "The Foundation's vision for the campus is to create a unique community by attracting a variety of non-profit and for-profit businesses, organizations and services to lease space in the buildings."

Memorial stone for Malagaites at Pineland Cemetery. *Author photo.*

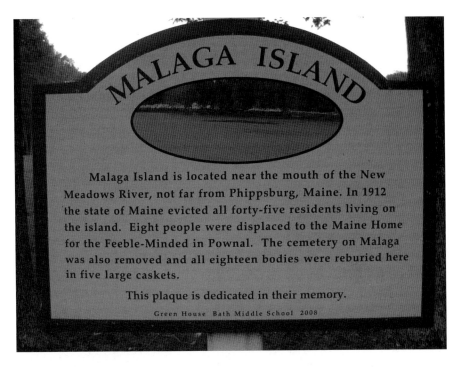

Plaque commemorating the Malaga story. *Author photo.*

Malaga Island is now known as Harbor Island and is under the protection of the Maine Coast Heritage Trust. In 2010, Maine's Governor Baldacci visited Malaga Island and apologized to the descendants of Benjamin Darling who gathered there to hear him speak on a rainy afternoon. In May 2012, Governor Paul LePage offered a second state apology, and that same year, the Maine State Museum in Augusta presented a one-year, award-winning exhibition project about the Malaga community called "Malaga Island, Fragmented Lives." Today there is a Facebook page for the descendants of the islanders, and the Maine Coast Heritage Trust sponsors walking tours of the island.

Part VI

HAUNTINGS AND CURSES

A Curse on the Old Squire

Looking for something to do in the Sebago Lakes Region on a rainy day? Among the suggestions on the Greater Bridgton Lakes Region Chamber of Commerce website (mainelakeschamber.com) are: get lost in a book, visit the Denmark Arts Center and learn about the "Captain Perley Curse." If you are reading this on a rainy day, you can tick two of the three suggestions off your list right now and then head to Denmark.

Enoch Perley was born in 1749. His name appears on a list of Revolutionary War soldiers who marched to Lexington, Massachusetts, under Captain Jacob Gould. The Battle of Concord and Lexington, "the shot heard round the world," took place on April 19, 1775, but Perley's unit missed the action. Perley's Revolutionary War service lasted just six days, which makes it unlikely that he was "Captain Perley," but Perley family legend does acknowledge a curse.

Perley, from Boxford, Massachusetts, came to the District of Maine in 1776. He married Anna Flint on March 17, 1778. Anna and her slave Chloe, a wedding gift from Anna's father (Flint had purchased four slaves from a Guinea slave trader) settled in what was then known as Bridges' Town on land owned by Enoch's father, Thomas Perley.

Enoch Perley was a man of small stature but large in ingenuity and intelligence. His four-hundred-acre farm was located in what is now known as South Bridgton on Route 107. According to Caroline D. Grimm, author of a novel titled *The Old Squire* (Voices of Pondicherry, vol. 3, publication pending), the eighteen-foot square Perley cabin was moved from the

original homestead to a peninsula on Highland Lake and is still there today. The structure has been incorporated into a larger building and is privately owned.

In colonial days, the title of Squire was used as an honorific for a wealthy landowner. Enoch Perley accumulated a lot of land on his own and became known as the "Old Squire." Amongst his neighbors, Perley was considered a wise man with a good business sense, and he held many important official positions in town, for a time acting as its magistrate. In addition to farming, Perley worked as carpenter, stonemason, smith, tanner and currier, hunter and fisherman. He was also a poet. One day, when he was out in the forest, he cut off a piece of birch bark and upon its smooth surface wrote a poem praising the bounty of his land and the gifts of its resources. He returned to the birch tree and nailed his verses to the tree trunk. Two lines that his great-granddaughter Rebecca Perley Reed remembered were: "Paper, whose sheets are fine and large, without a penny's cost or charge." Sometime later, Perley was surprised to find that his verses had been published in a Portland newspaper.

Enoch Perley's resourcefulness and frugality were legendary in his family. Reed remembers a small mirror with an odd irregularity in one corner. The mirror hung in the family's kitchen when she was a child. It always intrigued her, this oddly shaped looking glass, and it was not until she was an adult that someone told her that her great grandfather's skill at tinkering and repair had saved the mirror. Enoch had simply rebuilt a new frame to fit the mirror when its corner broke off.

The Old Squire accumulated a great deal of land and wealth during his life, but according to Reed, "The stress of his early fortunes probably conspired with his natural bent to render his hold upon these possessions a close one, and his reputation as a landlord gave him credit for a hardness not largely tempered with mercy." In other words, he was somewhat stingy. According to Reed, Perley once lent a sum of money to a widow. When she failed to repay the Old Squire on time, he confiscated her cow in payment for the debt. As Perley walked away with the cow, the widow stood in her doorway and cursed him, saying that no male of his name should live to manhood in the fourth generation of his descendants. In subsequent years, several of the male heirs died at a young age, and some Perley descendants gave birth only to daughters or remained childless. However, the curse missed its mark because one of his great-grandsons did survive to manhood.

In all fairness to the legacy of the Old Squire, records show that he generously contributed $3,355, a large sum in those days, for the

establishment of a permanent fund in support of a ministry in his community. On his deathbed, Perley ordered his sons to up the amount to $5,000 for the South Bridgton Congregational Church's ministerial fund. Perley died at the age of eighty in 1829, and the Congregational Church was established the same year with the hiring of Pastor Joseph Fessenden.

The Old Squire was buried in the family cemetery on his homestead. He willed his large estate to his two sons, John and Thomas, leaving not a bit of land or money for his three daughters. But family characteristics "run in the blood," as Perley's great-granddaughter writes in her memoir. She said that when her grandmother Rebecca Perley married, she carried to her new home nothing inherited except a "large birthright of the capacity, thrift, intelligence and sturdy faith which were to make her the true wife and mother to the end of her sixty-five years."

Unhappy Ghost at Edes Falls

Squire George Peirce Jr. was born in Watertown, Massachusetts, in 1734 and later acquired a large parcel of land in the Naples area of the Sebago Lakes Region. He first settled in what is now known as Edes Falls in 1774. Here, he built a cabin, a sawmill and a gristmill.

In some sources, the squire's name is spelled Pierce, just one of the many variations of this story. Peirce married Deborah Tarbelle, and they had four children. In 1789, one of the squire's neighbors, a young man named McIntosh (another source says his name was McIntyre), began a liaison with Molly Peirce, the teenage daughter of Squire Peirce. When the squire objected to the romance, a drunken McIntosh became infuriated and attacked him with an axe. Peirce then hit the young man with a mallet (another source says it was a piece of lumber), killing him.

McIntosh's body fell into the millpond, and when it rose to the surface, it was retrieved and buried on the right bank of the Crooked River near Peirce's mill. When heavy spring rains washed out the body, some Edes Falls residents claimed to see the ghost of the young man flitting back and forth across the river near the empty grave. The body was reinterred in the same spot, and the ghost departed.

Not long after, the body washed out a second time, and again the ghost was seen near the empty grave. The body was buried a third time, but after that, whenever flooding was expected, folks would see the ghost anxiously crossing and re-crossing the river, in fear they thought, of its body washing out of its waterside grave. Finally, the body was relocated

The village of Edes Falls, circa 1895, where George Peirce first settled in 1774. *Naples Historical Society.*

to higher ground just to the right of the bridge, and McIntosh's ghost was never seen again.

What happened to Squire Peirce? After McIntosh died, Peirce turned himself in to the authorities and was tried at a Portland court beginning on June 29, 1790. He was convicted of manslaughter (another source says he was acquitted) and sentenced to eight months in prison. Reportedly, Peirce wrote a book while he was imprisoned.

Legend says that after Peirce's release, the ghost of the man he murdered drove him out of Edes Falls in 1792, to resettle in nearby Naples where he became the first citizen of that village, built a grand house known as the Manor and established another mill. The beautiful, brick Federalist-style house was used as an inn for several decades. The Manor still stands today on Route 302 and is used as a private residence. Peirce also served as Naples's first physician, surgeon and lawyer. He died in Naples in 1801 and is buried in the town he founded.

THE LEGEND OF PULPIT ROCK

A large boulder called Pulpit Rock was once located off Route 302 in Raymond, near Thomas Pond. Old-timers remember it as a ledge to which people added rocks until the structure resembled a pulpit. But there may be other legends responsible for its naming. Reportedly, Pulpit Rock was a favorite spot of young Nat Hathorne, who liked to read there, and it may have inspired the setting for some of his stories. There is a short account of the rock and its legend in *Hawthorne's First Diary*:

> *This morning walked down to the Pulpit Rock Hill, and climbed up into the pulpit. It looks like a rough place to preach from, and does not seem so much like a pulpit when one is in it, as when viewing it from the road below. It is a wild place, and really a curiosity. I brought a book and sat in the rocky recess, and read for nearly an hour. This is a point on the road known to all teamsters.*

The Native American legend that gave rise to the name Pulpit Rock would have been well known to young Nat, who loved to hear local stories from his aunt Susan Manning who lived across the street from the Hathornes. He also heard stories from the customers who gathered at his uncle Richard Manning's general store next door to his house. According to *Hawthorne's First Diary*, that is how young Nat learned about the legend that gave rise to the name of Pulpit Rock:

While on the bridge near the Pulpit, Mr. West, who lives not far away, came along and asked where I had been. On my telling him, he said that no money would hire him to go up to that pulpit; that the Devil used to preach from it long and long ago; that on a time when hundreds of them were listening to one of his sermons, a great chief laughed in the Devil's face, upon which he stamped his foot, and the ground to the southwest, where they were standing, sunk fifty feet, and every Indian went down out of sight, leaving a swamp to this day. He declared that he once stuck a pole in there, which went down easily several feet, but then struck the skull-bone of an Indian, when instantly all the hassocks and flags began to shake; he heard a yell as from fifty overgrown Pequots; that he left the pole and ran for life. Mr. West also said that no Indian had ever been known to go near that swamp since, but that whenever one came that way, he turned out of the road near the house of Mr. West, and went straight to Thomas Pond, keeping to the eastward of Pulpit Rock, giving it a wide berth. Mr. West talked as though he believed what he said.

Hawthorne scholars speculate that his boyhood experiences in the Sebago Lakes Region provided the writer with some of the fodder for his fiction. Quite likely, Pulpit Rock and the swampy area just below it inspired the setting for "Young Goodman Brown," a short story Nathaniel Hawthorne published in 1835. In this story, a ceremony is carried out at a flame-lit rocky altar in a haunted New England forest. The story is set in the seventeenth century during the Salem witch trials at which Nat's great-great-grandfather John Hathorne was a judge. In the tale, the character of Goodman Brown sells his soul to the devil.

According to Pamela W. Grant of the Raymond Casco Historical Society, Pulpit Rock was destroyed in the 1950s when Route 302 was straightened, and the loose rocks were carried off by townspeople who wanted them as souvenirs. The Raymond Casco Historical Society plans to mark the old site of Pulpit Rock with a commemorative marker.

PHANTOM OF THE POLAND SPRING RESORT

S ome of the workers at the Poland Spring Inn in Poland, Maine, believe that their workplace is haunted by none other than Hiram Ricker, the founder of the resort. They claim to have seen his spirit walking in the hallways. They sometimes hear his voice coming from vacant rooms or his footsteps echoing in the lobby. He has been known to play tricks on the staff by rearranging objects.

Hiram, the son of inn and tavern keepers Wentworth and Polly Riccar (the family later changed the spelling to Ricker because of anti-German sentiment), was born in 1809. According to biographer Howard Dean, Hiram had a nasty temper and liked to fight. He was not well liked by either his acquaintances or his family when he was a young man. In 1833, Hiram decided to hightail it out of Poland to the nearby city of Portland. On March 15, after he had spent all his money on whiskey, he went drunkenly out into the street, where he collided with a well-dressed man, knocking the man down into the mud. The angry man threatened litigation against Hiram, so Hiram's father shipped the boy off to Boston to avoid a lawsuit. The well-dressed man was Maine poet Henry Wadsworth Longfellow, and we'll get back to him later in this tale.

When Hiram's father died in 1837, Hiram returned to Poland and took control of the family inn and tavern business. In 1859, Hiram Riccar began bottling the water from the spring on the property because he had long believed it had curative powers. As a young man, Hiram had suffered from a chronic stomach ailment for many years, and one day decided to go on a

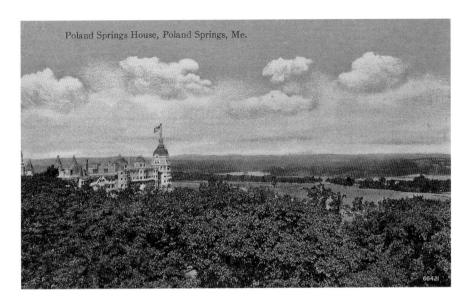

Poland Springs House, Poland Springs, Me.

Early postcard view of the Poland Springs House. *Author collection.*

spring-water diet for a week. Miraculously, he was cured of his ailment and became convinced that the water from the spring on his land had medicinal properties. Other members of his family had also claimed to be cured by the water. Hiram decided to bottle the water and offer it for sale, and by 1870, commercial sales had grown to five thousand barrels annually. An ad in an 1894 issue of the *Cambridge Tribune* promised the spring water as "the first known solvent, neutralizer and eliminator of uric acid from the bladder and kidneys. A diuretic of unfailing power, mild but pure. The dreaded effects of fevers, scarlet, malaria and typhoid particularly, are entirely overcome by a free use of Poland Water."

Poland Spring water has been quenching thirsts for more than 155 years. The present-day Poland Spring Resort on Route 26 now includes three inns, ten cottages, three restaurants, tennis courts, a golf course and a driving range. On its grounds are two museums and the original springhouse, also open to visitors. The Poland Spring Museum and Environmental Education Center display memorabilia from the facility and scientific information about natural spring water.

Hiram turned over the business to his son in 1869 and died in 1893. But some claim that he never left the resort property. According to an article in the *Portland Press Herald*, paranormal activity has been reported in the Presidential Inn, the five-bedroom Hiram Riccar Cottage and the Maine

Inn, especially in the library. Perhaps it is the ghost of Hiram Ricker, or maybe other spirits wander the halls. Do you believe in ghosts? Apparently, Longfellow did, as evidenced by his verses in the poem "Haunted Houses":

All houses wherein men have lived and died
Are haunted houses. Through the open doors
The harmless phantoms on their errands glide,
With feet that make no sound upon the floors.

We meet them at the door-way, on the stair,
Along the passages they come and go,
Impalpable impressions on the air,
A sense of something moving to and fro.

CURSED IN NAPLES:
A STATUE'S REVENGE

The Naples Historical Society Museum and Information Center is housed in a tidy white building tucked away on the village green behind the Methodist church. It is open only a few days a week even in high tourist season, and its collection is eclectic and unusual.

In one corner of the building, behind a wooden barricade, stands a seven-foot-tall Chinese statue carved from a single piece of wood, covered with plaster and decorated with gold leaf. The statue is dressed as a warrior, with clasped hands and a Mona Lisa smile. The figure looks benign enough, and the museum brochure says the statue probably depicts an alms giver or guardian, perhaps supplicating a Buddhist deity. Small carvings of devilish looking Pekinese dog faces decorate the body. The breed was once proud companion to Chinese Buddhist monks.

The statue is in need of restoration, and Naples Historical Society president Mary Watson says the job is estimated at $20,000, something the organization cannot afford right now. On a table near the statue is a stack of brochures relating the story of how the idol came to reside in the picturesque Sebago Lakes Region town of Naples. It is an incredible tale of piracy, adventure on the high seas and a mysterious curse apparently caused by the Chinese statue.

Brothers Charles and Ruben Hill of Naples were ship owners and merchants engaged in the China tea trade of the 1800s. During the Boxer Rebellion of that era, the Chinese order of "Righteous and Harmonious Fists" was trying to drive all foreigners from China. Apparently, the Hill

Chinese statue on display in Naples Historical Museum and Information Center. *Naples Historical Society.*

Photo showing the cavity in the back of the statue that may have held hidden treasure found by the Hill brothers. *Author photo.*

brothers took advantage of the upheaval at the time in China and robbed a temple, taking the statue that is now on display in Naples, as well as two other smaller figures. The scoundrels brought the statues home to Naples, and one legend says they discovered $300,000 worth of jewels hidden inside a cavity in the back of the statue.

The Hill brothers decided to spend the money by building a grand sixteen-room mansion and carriage house high on the hill above Long Lake, just a mile or so west of the village. They named the house "Belvue Terrace" and displayed the statue in the center of the home's main hallway. But soon, a

series of tragedies began that caused the townspeople to conclude that the statue had brought a curse to the property and the people who lived on it.

First, Charles Hill fell ill with a fever on his way back to China and died. Soon after, his brother, Ruben, was killed in an automobile accident. Heirs to the property believed that the statue was cursed, so they donated it to the Boston Museum of Fine Arts. The two smaller statues were reportedly thrown into Long Lake and never seen again. But the tragedies did not stop even though the statue was no longer in residence—the disasters continued for years. Subsequent owner John White's son Charles, a writer and poet who lived in the house with his parents, died mysteriously in Portland. Charles had published a book called *By the Sea*, and coincidentally his dead body was discovered on the Portland waterfront. Although his death was recorded as a suicide, some think it was more likely a murder by gunshot. Next, Charles Soden and his wife bought the mansion and renamed it the Hayloft. It was used as a restaurant and gift shop for tourists. Charles Soden hanged himself in 1936, and within a year, his widow died mysteriously and unexpectedly.

When Philip and Dorothy Clarke purchased the property, they renamed it Serenity Hill. In February 1951, a terrible fire destroyed all the buildings except the carriage house. Philip's body was found in the basement of the burned out house. Dorothy, who was recovering in the hospital from a bad fall, was not at home at the time of the fire. However, she never

The Hayloft Tea Room and Gift Shop in Naples. *Naples Historical Society.*

recovered and died soon after in a psychiatric hospital. In the years after the fire, the Serenity Hill carriage house was operated as a dance hall. It developed a rather unsavory reputation, according to the locals, and when it closed, the townspeople thought the curse had finally come to an end. But no. In the late 1970s, the property was used by a church congregation. The pastor put his mobile home on the old foundation of the burned-out building. When the pastor absconded with the church's funds, the church disbanded and the congregation dispersed. Next, the property was turned into a miniature-golf course and restaurant. After the manager's son died of leukemia, the property was again sold and today there is a self-storage business at the site.

In the early 1970s, the members of the Naples Historical Society felt that it was time for the statue to return to the village. Member Robert Dingley began to petition the Boston Museum of Fine Arts, where the statue was stored in the basement. The museum had displayed the statue only briefly for a few years around 1889. Through Dingley's efforts, the statue was returned to Naples in the back of a station wagon, according to Watson. Today, the statue proudly (and, one would hope, happily) guards the very interesting historical museum on the Naples Village green.

SPIRITED BURIAL GROUNDS

Whether you believe in ghosts or not, visits to the Anderson Cemetery (also known as the old Smith Burying Ground) and the Hunnewell Cemetery off River Road in Windham are sure to send shivers down your spine. Most of the cemeteries' residents lived in the late eighteenth and early nineteenth centuries.

The Anderson Cemetery is located on a dirt road on the right as you are heading toward Westbrook on River Road. There is no sign to indicate there is a cemetery on this road. It looks like someone's driveway, except there is no mailbox at the entrance. If you miss that road and see the sign for the Hunnewell Cemetery on the right a few yards down the road, you've missed the entrance to the Anderson Cemetery. The Hunnewell Cemetery is small and overgrown and located on private property, but you can look at it from the road. Many of the stones are broken or toppled. One of the more interesting sections is the Hunnewell lot, enclosed by a crumbling granite curb. On the lot is a cast-iron structure resembling a fireplace. On the "hearth" is a pair of andirons on which rests a wooden frame with a glass front. The frame is empty now, but according to a *Lewiston Journal* article reprinted in Frederick Dole's book, the case once enclosed a printed genealogy of the Hunnewell family, beginning with Roger who died in 1654, and ending with Charles H., who was at the time the article was written (1903) still living on the family homestead. The record was printed on white paper and decorated with pictures of pastoral life. Another wooden frame, set in granite and covered with glass, once held the photographs of

Charles's father and mother, Zerubbabel (1786–1863) and Ann Mitchell Hunnewell (1790–1835). Charles and his two wives are buried in the same lot, and Charles's headstone contains two birthdates, the second indicating a religious conversion:

> *Charles H. Hunnewell*
> *Born Windham, Mar. 5, 1827*
> *Married Jerusha W. Small of Westbrook June 16, 1852*
> *Born in spirit Feb. 14, 1868*
> *Death at the end of eternity that never ends.*

According to the newspaper article, the frames were once painted pure white, but now they are rusted and the glass, though intact, is foggy and stained.

The nearby Anderson Cemetery is a much larger burial ground. It is well maintained and presents a sharp contrast to the Hunnewell Cemetery in appearance. It is easy to see why some folks think it is home to eerie supernatural entities. The Anderson Cemetery has been subjected to paranormal investigations for years. (If you are too frightened to go on your own paranormal investigation, you can witness several of them via YouTube online—just Google "Anderson Cemetery, Windham, Maine.") According to an online posting from a director of the Central Maine Paranormal Investigations (CMPI), paranormal activity in the cemetery has been reported in several forms, including: sightings of orbs, ecto mist and light rods; EVPs (Electronic Voice Phenomenon) or spirit voice imprints; cold spots; technical problems and equipment malfunctions; sightings of the ghost of a Native American astride a horse; sightings of a ghost named Eleanor, accompanied by the scent of lilacs; sightings of the ghost of a young man in a dark shirt and white pants; and unexplainable sounds, such as a horse-drawn carriage coming down the lane and chains clinking.

Some have reported that visitors to the cemetery have returned to their parked cars to find them moved five or six feet from where they left them. Sometimes the car doors are found wide open. There are four areas in the cemetery where paranormal investigators like to work. A sunken road leads to the back corner of the cemetery, close to the woods, where apparitions have been sighted. This section of road is barricaded, so you will have to walk down it. A second location is the Anderson family crypt, where strange sounds have been reported. This tomb was erected in 1894 to honor John Anderson, a mayor of Portland. The granite face is said to be a copy of the Washington tomb at Mount Vernon. One of the inscriptions reads:

John Anderson
Second son of Abraham and Lucy Anderson of Windham
Born on Home Farm, July 29, 1792
Died at his residence in Portland,
Aug. 21, 1853

Ann Williams Jameson
Wife of John Anderson
Born Oct. 14, 1804
Died May 13, 1879

The peculiar looking tomb door was designed to resemble a bank vault door being fastened with a combination lock, but no one among the living knows the combination. The Anderson family homestead, built in the early 1700s and today known as Maplewood Farm, is located on River Road near the cemetery. According to the Windham Historical Society website, it is still owned by Anderson descendants, and each summer they gather from all over the country for an annual family reunion.

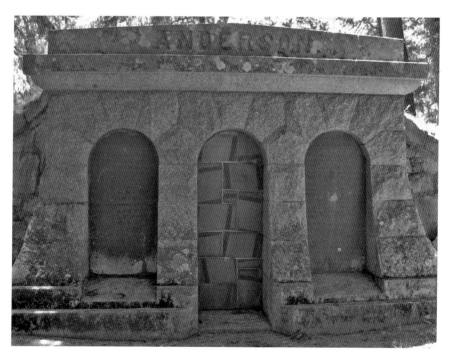

Anderson family crypt at the Anderson Cemetery, Windham. *Author photo.*

Open crypt, or "den," at the Anderson Cemetery, Windham. *Author photo.*

Close to the front of the cemetery is a burial mound topped with a flat tablet flanked by two upright stones, another favorite spot for paranormal investigators. This site is dedicated to an American soldier, and on the day I visited, it was decorated with an American flag. Why it is elevated from the surrounding graves is anybody's guess.

In the back of the cemetery at the end of the sunken lane next to the tree line is an open crypt or "den" where paranormal investigators have reported seeing a male spirit. This crypt is mounded and covered with vegetation, but it does not have a marker or inscription. What happened to the doors? Or was this structure simply abandoned before it was finished? For that matter, where is the body for which this crypt was built? The Anderson Cemetery is peaceful and serene, but it leaves the visitor with many more questions than answers.

Are the sounds coming from the Anderson crypt the voices of spirits trying to communicate with the living? Or are those the sounds of animals burying acorns? Is that orb in the photograph the manifestation of a departed soul? Or is it just light reflecting off a speck of dust on the camera lens? Do ghosts play tricks on us by moving our parked vehicles? Or did the driver just forget where she left the car? If apparitions are the disembodied spirits of the dead, then who were they in life?

GHOSTLY HITCHHIKER ON ROUTE 26

W ould you recognize a spirit if you encountered one?

Vanishing hitchhiker stories are plentiful and common enough throughout the country. The most typical story involves a driver who stops to give a woman (usually young and pretty) a ride and then she mysteriously vanishes during the course of the ride. A variation of this tale is the female hitchhiker who gets out of the car but leaves something behind. When the driver tries to find the woman later, he discovers that the person he is looking for died years ago.

Appeal of vanishing hitchhiker stories has been depicted in media with the films *Return to Glennascaul* (1951) and *Mr. Wrong* (1985), in literature with Washington Irving's novel *The Girl with the Velvet Collar* and in popular culture with K-Mart's vanishing hitchhiker commercial for its Route 66 jeans.

Here is a recent vanishing hitchhiker story from the Sebago Lakes Region, supposedly direct from an original witness. Whether you believe it or not, it is a matter of public record, according to a *Sun Journal* article by reporter Mark LaFlamme. It goes like this: on July 11, 2009, a Mechanic Falls police officer stopped to check on a teenage driver named David who was frantically flashing his headlights. The sixteen-year-old was clearly upset. He said that he had picked up a young woman hitchhiker on Route 26 in Poland who asked him to take her to the church on Route 11. It was 2:00 a.m.

David said the woman got into his Camaro, wrapping her white glowing gown around her. She told David she was late to a wedding. When David pulled up in front of the church, he said that the woman spoke to him, saying,

"There is a cop coming." David looked out the window and, sure enough, saw a police cruiser drive by him. When he turned back to his passenger, she was gone. David looked all around for the woman but did not see her.

The police officer filed his report, and the story was reported in the August 6, 2009 edition of the *Lewiston-Auburn Sun Journal*. In the story, LaFlamme states, "David relates his tale with excitement but without the kind of rhetorical battering you find in those who are trying to convince you of a lie." LaFlamme thinks that David at least believed that he saw something, and LaFlamme says that he has heard from others who claim to have come across the hitchhiker on Route 26. Some accounts are more credible than others, he said, and the Route 26 hitchhiker tale has several versions. In one story, the hitchhiker is a ghost of a young girl in a prom dress; in another, she is Mary Knight, who was brutally murdered in her own bed in 1856. In yet another story, she is a bride struck and killed by a car on the way to her wedding in the 1930s. This last account is the best fit for David's experience. Either way, the hitchhiker asks for a ride but disappears before reaching her destination.

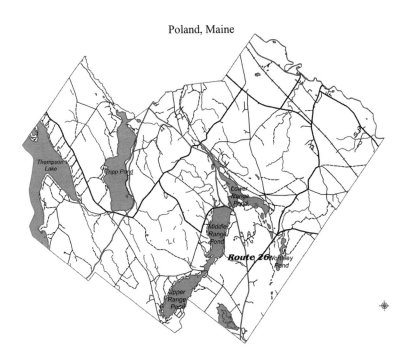

Map of Route 26 running through the center of Poland, location of the last sighting of the ghostly hitchhiker. *Courtesy of John Maloney, Androscoggin Valley Council of Governments.*

Route 26. *Flikr Creative Commons by Doug Kerr.*

Many believe that the story of the ghostly hitchhiker of Route 26 is an "urban legend," from a phrase that entered the culture in the early 1980s with the publication of folklorist Jan Harold Brunvand's book on the subject, titled *The Vanishing Hitchhiker: American Urban Legends and Their Meanings*.

Urban legends are cautionary tales.

BIBLIOGRAPHY

CHAPTER 1

Drake, Samuel G. *Drake's Book of Indians of North America*. 1833. Scituate, MA: Digital Scanning, Inc., 2001.

Hunnewell, Sumner. "A Doleful Slaughter Near Black Point." *The Maine Genealogist*. (August 2003): 99–120.

Sturtevant, Celia, and the Maine Writers Research Club. "The Story of the Saco River." In *Maine Indians in History and Legend*. Portland, Maine: Severn-Wylie-Jewett Co., 1952, 149–50.

CHAPTER 2

Helkes, N.M. "The Legend of Sebago Lake." *Lewiston Evening Journal*, March 27, 1920, 9.

Higgins, Pat. "Joseph Frye: Maine Proprietor and Soldier." The Maine Story. http://www.mainestory.info/ (accessed August 1, 2014).

Jones, Herbert Granville. *The Amazing Mr. Longfellow*. Portland, ME: The Longfellow Press, 1957.

————. *Sebago Lake Land*. Freeport, ME: The Cumberland Press, 1949. Reprinted 1965, 1982.

Knight, Ernest H. *Historical Gems of Raymond and Casco*. Raymond, ME: Raymond-Casco Historical Society, 1996.

CHAPTER 3

Dole, Frederick Howard. "Two Captures of Joe Knight." In *Sketches of the History of Windham, Maine, 1734–1935: The Story of a Typical New England Town*. Westbrook, ME: H.S. Cobb, 1935, 31–34.

Soldier, Kay. "It Happened in Windham: Kidnapped by the Indians." *Lakes Region Weekly*, December 20, 2013.

————. "It Happened in Windham: Naming the Inkhorn." *Lakes Region Weekly*, June 6, 2014.

Watson, Stephen Marion. "New Marblehead, Now Windham, Maine: Indian Troubles and Military Affairs." *Maine Historical and Genealogical Recorder* 5, 225–33. Portland, Maine: S.M. Watson, Publisher, 1888.

CHAPTER 4

Dole, Frederick Howard. "Final Contest with the Indians." In *Sketches of the History of Windham, Maine, 1734–1935: The Story of a Typical New England Town*. Westbrook, ME: H. S. Cobb, 1935, 38–44.

CHAPTER 5

Jones, Herbert. *Sebago Lake Land*. Freeport, ME: The Cumberland Press, 1949. Reprinted 1965, 1982.

Knight, Ernest H. *Historical Gems of Raymond and Casco*. Raymond, ME: Raymond-Casco Historical Society, 1996.

————. *The Origin and History of Raymondtown.* N.p.: Privately printed, 1974. Reprinted 1996.

CHAPTER 6

Conrads, Margaret C. "Nicholas Winfield Scott Leighton." In *American Paintings and Sculpture at the Sterling and Francine Clark Art Institute.* N.p.: Hudson Hills, 1990, 120.

Lewiston Saturday Journal. "Scott Leighton, Insane—Eminent Artist Taken to the Asylum." January 5, 1898, 7.

Rand, John Clark, ed. "Nicholas Winfield Scott Leighton." In *One of a Thousand.* Boston: First National Publishing Co., 1890, 372–73.

CHAPTER 7

Bridge, Horatio. *The Personal Recollections of Nathaniel Hawthorne.* New York: Harper and Brothers Publishers, 1893. http://www.eldritchpress.org/nh/hb03.html (accessed August 1, 2014).

Jones, Herbert Granville. *The Amazing Mr. Longfellow.* Portland, ME: The Longfellow Press, 1957.

Longfellow, Henry Wadsworth. *The Letters of Henry Wadsworth Longfellow.* Vol. 5. Cambridge, MA: Presidents and Fellows of Harvard College, 1982.

————. "Songo River." *The Complete Works of Henry Wadsworth Longfellow.* Boston: Houghton, Mifflin & Co., 1893. http://www.bartleby.com/br/356.html (accessed August 1, 2014).

CHAPTER 8

Elden, Alfred. "Man Who Moved a Mountain—His Memory to Be Perpetuated by a Bridle Path up Rattlesnake, Casco." *Lewiston Evening Journal,* February 25, 1939.

Knight, Ernest H. *Historical Gems of Raymond and Casco*. Raymond, ME: Raymond-Casco Historical Society, 1996.

CHAPTER 9

Allen, Ned. *Images of America: Bridgton*. Charleston, SC: Arcadia Publishing, 2008.

Barnabee, Henry Clay. *My Wanderings: Reminiscences of Henry Clay Barnabee*. Boston: Chapple Publishing Co., Ltd., 1913.

Emerson, Walter. *When North Winds Blow*. Lewiston, ME: Lewiston Journal Co., 1922.

New York Times. "Henry Clay Barnabee Dies in his 85th Year." December 17, 1917 http://query.nytimes.com/gst/abstract.html?res=9502E0DF1E3B E03ABC4F52DFB467838C609EDE (accessed February 2014).

CHAPTER 10

Grant, Maxwell. "Chain of Death." *Shadow Magazine* 10, no. 4, July 15, 1934.

Knapp, Louise M., and the Gray Historical Society. *Images of America: Gray, Maine*. Charleston, SC: Arcadia Publishing, 1999.

Murray, Will. *The Duende History of the Shadow Magazine*. Greenwood, MA: Odyssey Publications, Inc., 1980.

Rauscher, William V. "Walter B. Gibson—Wizard of Words." The Magical World of William V. Rauscher. Mystic Light Press, March 20, 2014. http://www.mysticlightpress.com/index.php?page_id=131 (accessed January 2014).

Shimeld, Thomas J. *Walter B. Gibson and the Shadow*. Jefferson, NC: McFarland & Co., Inc., 2003.

Chapter 11

Irvine, Andrew David. "Alfred North Whitehead." In *The Stanford Encyclopedia of Philosophy*, edited by Edward N. Zalta. Last modified winter 2013. http://plato.stanford.edu/archives/win2013/entries/whitehead/ (accessed March 2014).

Lewiston Sun Journal. "Gray News." July 2, 1945, 10.

Price, Lucien. *The Dialogues of Alfred North Whitehead as Recorded by Lucien Price.* Boston: Little, Brown and Company, 1954.

Chapter 12

"History and Historical and Archeological Resources." Town of Raymond, Maine. www.raymondmaine.org/sites/default/files/webfm/town (accessed March 5, 2014).

Knight, Ernest H. *Historical Gems of Raymond and Casco.* Raymond-Casco Historical Society, 1996.

Chapter 13

Erlich, Gloria. "Who Wrote Hawthorne's First Diary?" *Nathaniel Hawthorne Journal* (1977): 27–70.

Hawthorne, Elizabeth Manning. "The Boyhood of Hawthorne." *Wide Awake* 33 (1891): 500–18.

Hawthorne, Julian. *Nathaniel Hawthorne and His Wife.* New York: James R. Osgood and Co., 1884.

Lathrop, George Parsons. *A Study of Hawthorne.* (1876) http://www.gutenberg.org/etext/8350 (accessed January 2014).

Little, Edward. "A Downeast Huck Finn?: Samuel Pickard, Hawthorne's First Diary and Bowdoin College." *Bowdoin Magazine*, March 17, 2011.

http://www.bowdoin.edu/magazine/features/2011/downeast-huck-finn.shtml (accessed February 2014).

Pickard, Samuel T. *Hawthorne's First Diary With an Account of its Discovery and Loss*. Boston: Houghton, Mifflin and Co., 1897.

———. "Is Hawthorne's First Diary a Forgery?" *The Dial*. (1901): 155.

Ponder, Melinda. "Nathaniel Hawthorne: The Morning of His Life, His Boyhood Years and Emergence as an Artist." Hawthorne in Salem, 1981. http://www.hawthorneinsalem.org/Life&Times/BiographicalInfo/Earlylife/MorningOfHisLife.html (accessed February 2014).

Ramsey, David S. "Nathaniel Hawthorne's Boyhood in Maine." *Studies in Language and Culture* 26 (2005): 207–19.

Stewart, Randall. "Recollections of Hawthorne by His Sister Elizabeth." *American Literature* 16, no. 4 (January 1945): 316–31.

Wineapple, Brenda. *Hawthorne: A Life*. New York: Random House, 2003.

Chapter 14

Andrews, Edward Deming, and Faith Andrews. *Visions of the Heavenly Sphere*. Charlottesville: The University Press of Virginia, 1969.

Hadd, Brother Arnold. *Creating Chosen Land: Our Home from 1783–2010*. Gallery guide. New Gloucester, ME: United Society of Shakers, Sabbathday Lake, Inc., 2010.

Morse, Flo. *The Shakers and the World's People*. Hanover, NH: University Press of New England, 1980.

Olsen, Brad. *Sacred Places in North America: 108 Destinations*. San Francisco, CA: CCC Publishing, 2008.

Paterwic, Stephen J. *The A to Z of the Shakers*. Lanham, MD: The Scarecrow Press, Inc., 2009.

"Sabbathday Lake Shaker Village, New Gloucester, Maine—A National Historic Landmark." http://www.shaker.lib.me.us/index.html (accessed September 2014).

Stein, Stephen J. "Inspiration, Revelation, and Scripture: The Story of a Shaker Bible." Worcester, MA: American Antiquarian Society, 1996. http://www.americanantiquarian.org/proceedings/44539469.pdf

———. *The Shaker Experience in America*. New Haven, CT: Yale University Press, 1994.

Wertkin, Gerard C. *The Four Seasons of Shaker Life: An Intimate Portrait of the Community at Sabbathday Lake, Maine*. New York: Simon & Schuster, Inc., 1986.

CHAPTER 15

Crabtree, Allen. "Was There an Underground Railroad Station in Sebago?" *Maine Farmhouse Journal*, March 10, 2005. http://www.crabcoll.com/journal/underground.htm (accessed August 2014).

Grimm, Caroline. *Beneath Freedom's Wing*. Bridgton, ME: Voices of Pondicherry, 2014.

———. Bridgton Public Library presentation. July 11, 2014.

Maine Historical Society. "Peopling Maine." Maine History Online. Last updated 2000–10. https://www.mainememory.net/sitebuilder/site/879/page/1290/display?page=3 (accessed August 2014).

Price, H.H., and Gerald E. Talbot. *Maine's Visible Black History*. Gardiner, ME: Tilbury House Publishers, 2006.

Seibert, Wilbur H. *The Underground Railroad from Slavery to Freedom: A History: The First Chronicle of Its People*. New York: MacMillan Co., 1898.

CHAPTER 16

Hill, George T. *History, Records and Recollections of Gray, Maine*. Vol. 1. Portland, ME: Seavey Printers, 1978.

"How Maine's Samuel Mayall Brought America its First Woolen Mill." New England Historical Society. http://www.newenglandhistoricalsociety.com/maines-samuel-mayall-brought-america-first-woolen-mill/ (accessed August 2014).

CHAPTER 17

Hanna, David. *Knights of the Sea: The True Story of the Boxer and the Enterprise and the War of 1812*. London: Penguin Books, Ltd., 2012.

Romano, Ron. "Bartlett Adams." Presentation for New Gloucester Historical Society. May 15, 2014.

CHAPTER 18

Agnew, Aileen B. "Big Timber: The Mast Trade." Maine Historical Society: Maine History Online. 2010. http://www.mainememory.net/sitebuilder/site/283/page/546/display (accessed January 2014).

"Curtis Gum Company." *Maine History News*, August 3, 2012. http://touringmaineshistory.wordpress.com/2012/08/03/the-curtis-gum-company/ (accessed January 2014).

Knight, Ernest H. *Historical Gems of Raymond and Casco*. Raymond, ME: Raymond-Casco Historical Society, 1996.

Morrison, Alvin Hamblin. "Sebago-Presumpscot Anthropology Reports." *Mawooshen Research*, 2013. http://mawooshenresearch.com/sebago_Gay was a farmer who santhro/w2_masts_ox/c_w2_masts_ox.html (accessed March 2014).

New York Times. "Tons of Spruce Gum, Rich Maine Crop: It's Harvesting Profitable Work for Men Who Can Climb." May 22, 1913. http://query.

nytimes.com/gst/abstract.html?res=9C07E5DD173FE633A25751C2A
9659C946296D6CF (accessed March 2014).

CHAPTER 19

Dole, Frederick Howard. "Great Disasters—Powder Mill Explosions." In *Sketches of the History of Windham, Maine, 1734–1935: The Story of a Typical New England Town.* Westbrook, ME: H.S. Cobb, 1935, 108–10.

Wescott, Donald C., and Maurice M. Whitten. "Gunpowder for the Civil War—The Oriental Powder Mills of Gorham-Windham." Maine Historical Society. The Maine Memory Network E-connection. Last modified April 2014. https://www.mainememory.net/sitebuilder/site/2482/page/3973/display?use_mmn=1 (accessed August 2014).

Whitten, Maurice M. *The Gunpowder Mills of Maine.* Gorham, ME: Privately printed, 1990. Reprinted Windham Historical Society, 2012.

CHAPTER 20

Rogers, Ethel. *Sebago-Wohelo Camp Fire Girls.* Battle Creek, MI: Good Health Publishing, 1915. http://babel.hathitrust.org/cgi/pt?id=mdp.39015048493202#view=1up;seq=9 (accessed October 2, 2014).

Wohelo Camp (ca. 1919). National Film Preservation Foundation. http://www.filmpreservation.org/preserved-films/screening-room/wohelo-camp-ca-1919 (accessed October 2, 2014).

Wohelo Camps. "About." 2014. http://www.wohelo.com/ (accessed October 3, 2014).

CHAPTER 21

Knight, Ernest H. *Historical Gems of Raymond and Casco.* Raymond, ME: Raymond-Casco Historical Society, 1996.

McLaughlin, W.H. "The Death of Mr. and Mrs. Tarbox." *Portland Evening Express*. March 12, 1904, 10. http://freepages.genealogy.rootsweb. ancestry.com/~edgecomb/tarbox01.html (accessed January 2014).

Pickard, Samuel T. *Hawthorne's First Diary With an Account of its Discovery and Loss*. Boston: Houghton, Mifflin & Co., 1897.

Ponder, Melinda. "Nathaniel Hawthorne: The Morning of His Life, His Boyhood Years and Emergence as an Artist." Chapter 3 in *Hawthorne in Salem*. 1981. http://hawthorneinsalem.org/Life&Times/ BiographicalInfo/Earlylife/ch3.html (accessed March 5, 2014).

Shaw, Thomas. America Singing: Nineteenth-Century Song Sheets. Library of Congress, Rare Book and Special Collections Division. http://www. loc.gov/item/amss.as109000 (accessed January 2014).

CHAPTER 22

Soucy, D.L. "The Murder of Mary Knight." *Maine History News*, October 26, 2011. https://touringmaineshistory.wordpress.com/ (accessed August 2014).

"State vs. Knight." *Reports of Cases in Law and Equity Determined by the Supreme Judicial Court of Maine*. Vol. 42. Portland: Loring, Short & Harmon, 1858, 11–143. http://searchworks.stanford.edu/view/9555284 (accessed August 2014).

CHAPTER 23

Batignani, Karen Wentworth. *Maine's Coastal Cemeteries: A Historic Tour*. Camden, ME: Downeast Books, 2003.

Breed, Allen. "No Longer a Reproach, The Story of Malaga Island." In *Maine's Visible Black History* by H.H. Price and Gerald E. Talbot. Gardiner, Maine: Tilbury House Publishers, 2006, 69–75.

Kimball, Richard S. *Pineland's Past: The First Hundred Years*. Portsmouth, NH: University Press of New England, 2001.

Malaga Island: A Story Best Left Untold. Produced by WMPG and the Salt Institute for Documentary Studies. http://malagaislandmaine.org (accessed August 1, 2014).

"Pineland Farms, New Gloucester, Maine." Last modified 2014. http://www.pinelandfarms.org/ (accessed August 2014).

CHAPTER 24

Cram, Marshall. *An Address Delivered at the Dedication of the Town House in Bridgton.* Portland, ME: B. Thurston, Printer, 1852.

Loon Echo Land Trust. "A Walk Back in Times." *Loon Echo News,* winter/spring 2014.

Reed, Rebecca Perley. *The Story of Our Forbears.* Milwaukee: Press of the Evening Wisconsin Company, 1903.

CHAPTER 25

Dingley, Robert Jordan. *Now I Will Tell You…the Story of Naples, Maine.* Naples, ME: The Naples Historical Society, 1979.

Jones, Herbert. *Sebago Lake Land.* Freeport, ME: The Cumberland Press, 1949. Reprinted 1965, 1982.

Weber, Tom. "Haunting Tales." *Bangor Daily News,* October 31, 1990.

CHAPTER 26

Maine, A Guide "Down East." Federal Writers' Project, 1937. https://archive.org/details/maineguidedownea00federich (accessed July 2014).

Pickard, Samuel T. *Hawthorne's First Diary With an Account of its Discovery and Loss.* Boston: Houghton, Mifflin & Co., 1897.

Chapter 27

Bouchard, Stephanie, Shannon Bryan, Avery Yale Kamila, Bob Keyes and Ray Routhier. "Maine Haunts to Visit if You Dare." *Portland Press Herald*, October 28, 2010.

Dean, Howard. *The Poland Spring Story*. Federation of Historical Bottle Collectors, Spring 2004. http://www.fohbc.org/PDF_Files/PolandSpring_HDean.pdf (accessed March 2014).

Poland Water Advertisement. *Cambridge Tribune* 17, no. 8 (April 28, 1894).

Chapter 28

Citro, Joseph. "An Idol Revenge." *Cursed in New England: Stories of Damned Yankees*. Guilford, CT: Globe Pequot Press, 2004.

Naples Historical Society. "The Idol of Naples." Museum brochure.

Chapter 29

"Anderson Cemetery—Windham, Maine." Maine Ghost Hunters blog. September 10, 2008. http://strangemaine.blogspot.com/2008/09/anderson-cemetery-windham.html (accessed February 5, 2014).

Dole, Frederick Howard. "The Smith Cemetery." *Sketches of the History of Windham, Maine, 1734–1935: The Story of a Typical New England Town.* Westbrook, ME: H.S. Cobb, 1935, 144–46.

Farrington, Stacey, Director of Central Maine Paranormal Investigations (CMPI). Yahoo Groups post. November 18, 2007.

Windham Historical Society. "Other Old Houses—Anderson/Lord House." Last modified 2009. http://www.windhamhistorical.org/houses.shtml (accessed August 2014).

CHAPTER 30

LaFlamme, Mark. "Spectral lady hitches ride, vanishes." *Sun Journal*, August 6, 2009.

ABOUT THE AUTHOR

Marilyn Weymouth Seguin was born and educated in Maine and has spent parts of the last twenty-seven summers vacationing at camps in the Sebago Lakes Region. She recently retired from full-time teaching in the Writing Program in the English Department at Kent State University, so now she and her husband can spend even more time at their camp on Little Sebago Lake. Marilyn is the author of seventeen books and a member of the Maine Writers & Publishers Alliance and the Society of Children's Book Writers and Illustrators.

Marilyn Weymouth Seguin. *Photo courtesy of Jane Ann Turzillo.*

Visit us at
www.historypress.net
..
This title is also available as an e-book